Images of America
Lexington Firefighting

ON THE COVER: This photograph was taken at the dedication of the new Central Fire Station on East Third Street in June 1929. (Courtesy of Lexington History Museum, Malick Photographic Collection.)

IMAGES of America
LEXINGTON FIREFIGHTING

William M. Ambrose
and Foster Ockerman Jr.
Introduction by Chief Jason Wells

Copyright © 2021 by William M. Ambrose and Foster Ockerman Jr.
ISBN 978-1-4671-0727-3

Published by Arcadia Publishing
Charleston, South Carolina

Printed in the United States of America

Library of Congress Control Number: 2021938114

For all general information, please contact Arcadia Publishing:
Telephone 843-853-2070
Fax 843-853-0044
E-mail sales@arcadiapublishing.com
For customer service and orders:
Toll-Free 1-888-313-2665

Visit us on the Internet at www.arcadiapublishing.com

This volume is dedicated to the firefighters of Lexington, Fayette County, Kentucky, those men and women who dash into smoke-filled buildings to save those in peril from flames, especially those who failed to return.

Chief Louis A. Travis, 1944
Firefighter Henry H. McDonald, 1945
Capt. John C. Moynahan, 1950
Lt. Estill D. Rickerson Jr., 1971
Firefighter Robert W. Martin, 1986
Firefighter Charles H. Williams II, 1997
Lt. Brenda D. Cowan, 2004
Firefighter Joseph M. Vissing, 2015
Firefighter Matthew J. Logsdon, 2016

Contents

Acknowledgments		6
Introduction		7
1.	Early Era: 1790–1911	11
2.	Horseless Engines: 1911–1914	25
3.	Wars and Depression: 1914–1945	31
4.	Postwar Era: 1946–1973	53
5.	Merged Government: 1974–2021	99
6.	Fire Apparatus: 1871–2021	109
About the Lexington History Museum		127

Acknowledgments

This volume is based primarily upon the photographs taken by local photographer and former firefighter John P. Malick. He is the son of Chester H. Malick, a volunteer fireman. From an early age, John accompanied his father on fire runs. In the early 1950s, he began photographing fires and selling some of the prints to the local newspapers. At the age of 18, he joined the Air Force as a photography lab technician. After two years serving his country, he joined the Lexington Fire Department (LFD) in 1960. Assigned to Station No. 1, he achieved the rank of captain in the Arson Investigation Unit. Malick's tenure with the LFD lasted 12 years.

After 65 years in commercial photography, he had accumulated an extensive private photography collection of Central Kentucky. Malick generously donated his entire collection to the Lexington History Museum. Special recognition is given to Jeff Beard, who was instrumental in obtaining the collection for the museum.

Special gratitude goes to Maj. Trevor J. Cox of the LFD for providing invaluable assistance in researching this volume. The authors also wish to extend appreciation to Chief Jason G. Wells, Asst. Chief Scotty Whitt, firefighter Frank Handshoe, and Dr. David Greenlee of the Lexington Fire Department; firefighters Todd Houston and Chris MacFarlane of the Lexington Fraternal Order of Firefighters; Amy Caudill of the Bluegrass Airport; Susan Straub and Amy Wallot of the Lexington-Fayette Urban County Government; Peter Baniak, editor of the *Lexington Herald-Leader*; Deirdre A. Scaggs of the University of Kentucky Archives; Deputy Chief J. Winfrey Adkins Sr. of the Versailles Fire Department; and Capt. Lionel Gumm, LFD (retired), for their contributions while researching this volume.

Unless otherwise noted, all images appear courtesy of the John P. Malick Photograph Collection at the Lexington History Museum. Other images are courtesy of LFD, Lexington Fraternal Order of Firefighters (FOF), Lexington-Fayette Urban County Government (LFUCG) Dr. David Greenlee (Greenlee), Bluegrass Airport (BGA), Collection on Lafayette Studios, University of Kentucky Libraries (UK), and *Lexington Herald-Leader* (LHL).

Introduction

By 1780, Lexington had become a settlement with a dozen wooden cabins surrounded by a stockade to protect settlers from the British and the Native Americans. As Lexington grew from a pioneer stockade into a village, the concern of fire emerged as an increasing threat against the expanding number of wooden structures. To alleviate this growing fear, the Lexington Fire Company was organized in May 1790 and became the first fire department west of the Allegheny Mountains.

Firefighting in these early days required that all able-bodied men, often aided by women, show up to form a bucket brigade. The men who were part of the Lexington Fire Company, organized along the lines of a militia company, turned out to the fire with buckets, hooks, axes, and ladders to fight each blaze. In the early 1800s, Lexington was described by the poet Josiah Espy as the largest and most wealthy town in the West. In his essay "Athens of the West," he compared Main Street of Lexington to the appearance of Market Street in Philadelphia on a busy day and expressed little doubt that in a few years' time, Lexington would rival the most populous inland towns of the United States in both wealth and population. For these reasons, we know that the Lexington Fire Department has a long and distinguished history that can be traced back to nearly the inception of our community.

As part of a reorganization in April 1808, Lexington was divided into three geographic districts by the Union Fire Company, which had added its second fire company in 1798. In 1816, the Independent Fire Company was formed. Two years later, city trustees approved the purchase of "two of the newly invented Engines" built by Pat Lyon, who started making fire engines in 1794. These two engines, which were Philadelphia-style, were named *Independence* and *Lyon* and were staffed by the Independence and Union Fire Companies.

As with most flourishing towns, the City of Lexington became incorporated in 1832. That same year, the city council approved an ordinance that created the Lexington Fire Department, which consisted of two volunteer fire companies: Independence and Union. To keep up with the city's growth, in March 1839, the city council imposed a fire tax on each residence based on the assessed valuation of property within city limits. Over the next 10 years, and to help expand the fire department's capabilities, the city applied the $1,700 annual tax revenue toward the purchase of new fire apparatus, firehouses, and excavating cisterns to supply water during fires. In 1839, a third volunteer fire company, the Lyon Fire Company, was formed, thereby establishing three fire companies—Independent, Union, and Lyon—which operated seven different engine companies throughout the city.

The fear that originally led to the formation of the Lexington Fire Company in 1790 became a reality in August 1871, when two large fires destroyed significant portions of the city in quick succession. On August 14, the first fire began at the Barnes & Wood Drug Store on the southwest corner of West Main and South Upper Streets. By the time the fire was brought under control, 12 buildings were destroyed at a loss estimated at $68,000. The second fire occurred within just days of the first, but this time at Main Street and Broadway. The fast-spreading fire engulfed 18

buildings, mostly affecting Short Street, before the fire was finally extinguished. The second fire resulted in an estimated loss of $53,700.

Following these two large block fires, the department was once again reorganized, and the Lexington Fire Department as we now know it was created in September 1871. With an annual salary of $400, Stephen G. Sharp (1843–1923) was appointed fire chief. Captain Sharp, as he was known during the Civil War when he served with Gen. John Hunt Morgan, was a prominent Democrat, attorney, and politician. As part of the reorganization, at Chief Sharp's direction, the volunteer companies were disbanded, and three fire companies operating under the same department were established: Lexington Steam Fire Company No. 1, M.S. Dowden Steam Fire Company No. 2, and Hook & Ladder Company No. 1.

The department consisted of six men, five horses, and three pieces of apparatus and operated on an annual budget of $3,700, which included a $1.50 line item to feed Old Tom, the engine house cat whose job was to keep the mice and rats out of the stables and firehouses. These first members responded to approximately 20 alarms per year using two Silsby steam fire engines (*Lexington* and *M.S. Dowden*) that were each equipped with a hose reel. Although the buckets used by the original Lexington Fire Company had long been retired, the ladder wagon (*Hook & Ladder*) carried similar tools in extension ladders, hooks, and axes.

To improve efficiencies with notification of fire and water supply, two significant changes were implemented in January 1885. First, 40 call boxes were installed around town that rang a fire bell at Central Station with the specific call box number and automatically opened the stall doors. This method of notification carried forward the tradition that all members of the community played a key role in limiting the effects of fire. Second, 200 fire hydrants that were operated by the Lexington Hydraulic & Manufacturing Company (later Lexington Waterworks Company) were installed throughout the city to replace the old cisterns that were no longer meeting the water demands of steam fire engines. A third efficiency was implemented in 1886 when a police and fire commission was created with the purpose of removing politics from within the departments.

The first horseless engine in Lexington made its debut in 1911 and changed the fire service forever. Even though the citizens would lose their opportunity to cheer and chase after the horses as they charged toward danger, motorized fire apparatus improved response times to emergencies, and their superiority over horse-drawn engines was demonstrated daily.

In 1949, Earl R. McDaniel was appointed fire chief and led the department through many notable transitions, including significant growth of at least 11 new fire stations and the eventual merger of the city and county fire departments in 1972. Under his leadership, the department began administering employee physicals in 1952 and installed the first truck-mounted radios in 1954. In addition, services were expanded to include first aid in 1955, and the 56-hour workweek was established in 1962. In 1969, the first African American firefighter, John Drake, was hired, followed by the first female firefighter, Lisa Daly, in 1985. Chief McDaniel's contributions spanned 37 years and paved the way for future generations.

Around this same time, in 1973, the National Commission on Fire Prevention and Control released a report called "America Burning" that is credited with many of the forward-thinking changes that shaped the 1970s, 1980s, and 1990s. Key findings in that report include an emphasis on proactive rather than reactive firefighting practices in the form of public education, prevention, and increased job training for firefighters. The advent of the US Fire Administration, National Fire Academy, and the National Fire Incident Reporting System all have direct ties to the research and findings of the report. Ultimately, these entities laid the foundation for the modern fire service as we know it today.

The common theme of the fire service has been responding to the threat of property loss, injury, and death caused by fire. Our history shows intentional efforts to evolve with the changing needs of our community in order to always provide the best service possible. At present, the Lexington Fire Department continues to serve as the commonwealth's largest department providing progressive, all-hazard services to best meet the needs of our growing population. Operating out of 24 fire stations, our firefighters are all IFSAC I/II, EMT-B, and HazMat Ops certified. We provide full-time

fire prevention, education, and investigation programs, as well as structural and aircraft rescue and firefighting (ARFF), ALS (advanced life support) EMS, hazardous materials, and technical rescue services. During the past five years, we responded to over 304,000 local emergencies. With an authorized strength of 597 men and women, the LFD budget was just over $80 million in fiscal year 2021. The operational force of the department consists of 23 engine companies, 7 ladder companies, and 12 front-line ambulances. These resources are divided across three operational platoons and into five geographical districts. Each district is supervised by a major, and each platoon is supervised by a battalion chief.

The LFD continues to break barriers and make history with the appointment of our first African American fire chief, Keith Jackson, in 2011, followed by our first female fire chief, Kristin Chilton, in 2016. Under these administrations, the groundwork for more proactive initiatives was laid. In 2015, a community partnership with the American Red Cross was formed with the goal of installing free smoke alarms in every home that needs them. This program has led to more than 25,000 smoke alarms being installed in Lexington and is credited with saving 14 lives.

Similarly, in 2018 we launched our Community Paramedicine program, which enables firefighters to take a more comprehensive approach to the care of patients who have a high dependence on E-911. Through home visits, education, and individual assessments, we are helping patients get the help they need for the best overall outcome and not just a short-term solution. This translates into fewer patients in hospital emergency rooms and fewer readmits after a patient is discharged. Without a doubt, the Lexington Fire Department is saving lives and making a difference for the families living in Lexington-Fayette County.

Looking forward, we will continue to seek innovative ways to make Lexington an even safer place to live. This includes intentionally recruiting applicants who reflect the community we serve and investing time, energy, and resources into the improved holistic health of our firefighters. It is hard to quantify sacrifice, but our members work tirelessly each day for the benefit of the community and continue to endure as our department's greatest asset. It is because of them that I am encouraged by the direction our department is going and take pride in the positive impact we have on our community.

<div style="text-align: right;">
Chief Jason G. Wells

Lexington Fire Department
</div>

One

Early Era
1790–1911

Meeting Notice. The Lexington Fire Company, the first volunteer fire department west of the Alleghenies, was organized in May 1790 at Brent's Tavern. Two years later, Kentucky was admitted to the Union. A volunteer fire company was established as a public necessity against the common danger of fires, with all citizens required to form a bucket brigade to pass water to the fire crew.

At a meeting of a number of the members of the LEXINGTON FIRE-COMPANY, Pursuant to notice, at Capt. Thomas Young's Tavern, April 16, 1791.

Resolved that this company meet ſtatedly the firſt Saturday in every month, at capt. Young's Tavern, at 7 o'Clock in the evening, until otherwiſe ordered by this company.

Resolved, that the Secretary advertiſe the reſolution of this evening, appointing ſtated meetings in the next and ſucceeding Gazette's.

A true copy from the minutes.
Teſt
JOHN BRADFORD Secretary.

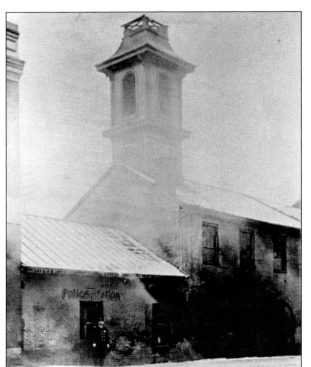

WATCH HOUSE. The old city watch house on Water Street dated to the 1820s, with the adjacent tower used to keep a lookout for fires. City watchman was a desirable job, paying five dollars per week; however, many watchmen were dismissed after being found asleep or drunk on the job.

INDEPENDENCE ENGINE HOUSE. The Independence Volunteer Fire Company's engine house was on the east side of Broadway between Short and Second Streets. The company was established in 1816 to cover Lexington's upper portion (east of Upper Street). In 1840, the Independent Fire Company operated the *Resolution No. 1* and *Independence* hand fire engines and the *Henry Clay* in 1852.

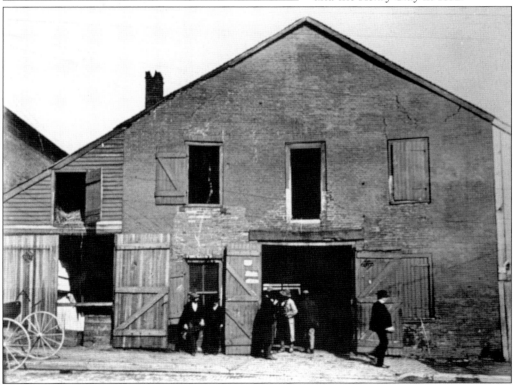

Lyon Engine House. The Lyon Volunteer Fire Company's house was on Limestone between Vine and High Streets. The company was formed in 1838 as the third volunteer company and was made up of Irish immigrants. In 1840, the company operated the *Lyon*, *Cataract*, and *Humane* fire engines. The property was sold in 1871 when the company was disbanded and became a church.

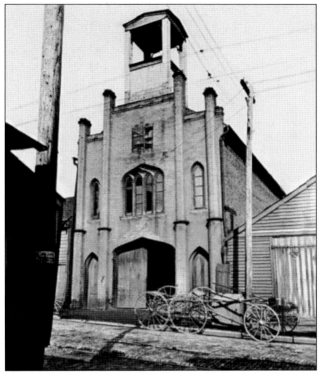

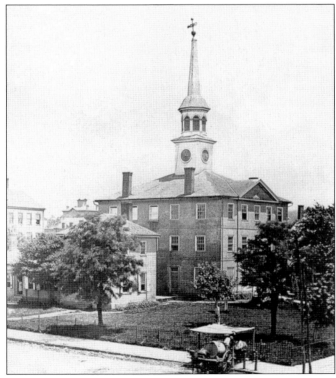

Fire Cisterns. The city built over 50 fire cisterns during the 1840s around the downtown area. These cisterns supplied water to the fire engines through a suction pipe. When the cistern was emptied, the engine was relocated to the next cistern. This photograph shows the water cart filling the cistern at the courthouse on Main Street.

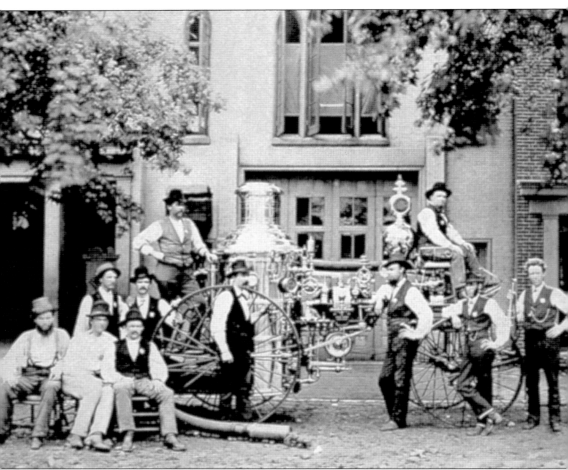

Silsby Steam Fire Engine. The new steam fire engine M.C. *Johnson* was photographed in front of the Central Fire Station on West Short Street when it was delivered in April 1876. Standing at far right is Chief Paul Conlon, standing on the rear of the engine is fireman James B. Gilroy, and seated is engineer William A. Metcalf. The Silsby Manufacturing Company built the engine. It had a capacity of 800 gallons per minute and cost $5,500. The engine was manned by three men: an engineer, fireman, and driver. The engineer was the highest paid at $60 per month, with the fireman and driver earning $40 and $50 respectively. Also responding to fires were two pipemen responsible for handling the hose. They were paid $8 per month. The fire chief also responded to fires and was paid a salary of $100 per year. Later, the minutes of the Lexington Fire Committee indicated that the chief's salary was doubled because "his duties were onerous . . . and the present salary of $100 entirely too low."

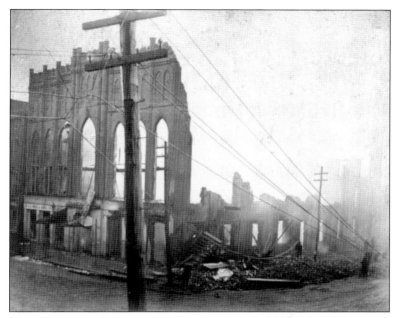

OPERA HOUSE. Built before the Civil War, the old performance hall on Main Street and Broadway's southeast corner was destroyed during an early morning fire on January 15, 1886. The Opera House and Express Office both operated from the hall. It was the scene of many public debates and events.

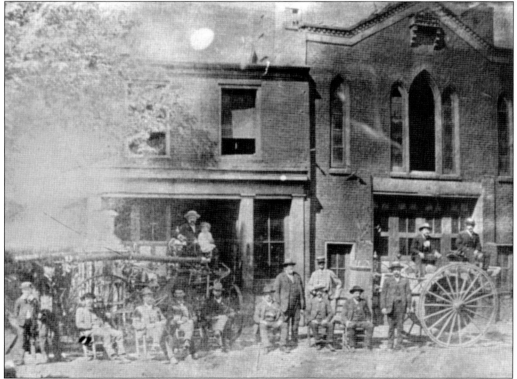

OLD UNION FIREHOUSE. The Silsby steam engine *M.C. Johnson* and hose reel operated from the Central Fire Station around 1886. The engine was housed in the old Union Volunteer Fire Company's engine house on West Short Street, erected in 1856. The entire roster of the department included five firemen and the chief.

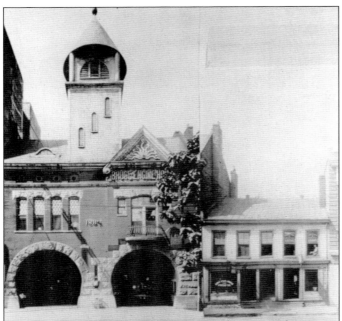

CENTRAL FIRE STATION. The new Central Fire Station was completed in 1888 on West Short Street, on the old Union Firehouse site. The old station was destroyed by fire earlier that year. The horses and apparatus were saved before the building was consumed. Two firemen polls were installed in the new building for a fast descent to the equipment below.

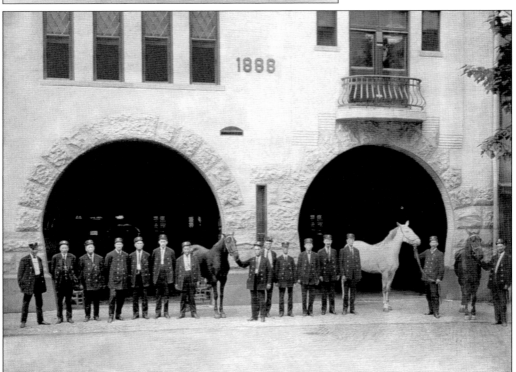

ROSTER, 1888. The 15 members of the Lexington Fire Department pose in front of the new Central Fire Station around 1888. The apparatus consisted of two steam engines and hose reels. The following year, the city purchased a wagon (the *Hook & Ladder*) equipped with seven ladders (the longest at 58 feet) pulled by a team of horses.

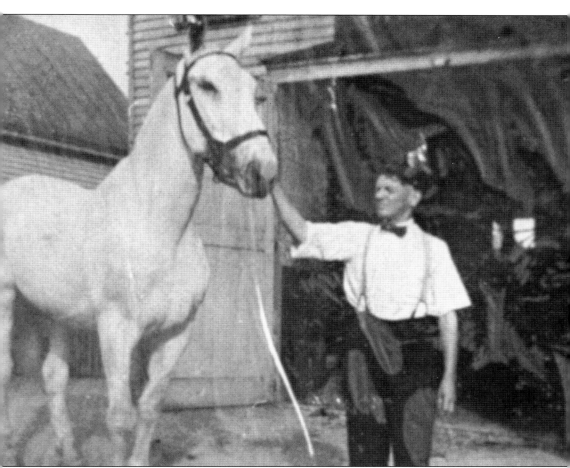

NAMES, NOT NUMBERS. Fire horses were named, not numbered. Drivers were responsible for the horses under their care. A new horse was trained at the sound of the fire bell to leave his stall and line up in front of the wagon. The stall doors automatically unlocked when the bell sounded. By the time the fireman arrived, the horses were waiting under the suspended quick fastening harness. At a fire, the horses were unhitched from the apparatus and removed from the immediate scene by the driver. Department regulations specified after a run "horses must be rubbed until they are dry and warm" and "horses shall be exercised at least two hours each day, from the first of April until the first of November, and one hour from the first of November to the first of April." In addition, "in exercising the horses, they must not be driven faster than an easy trot." Also, their front feet were stuffed weekly with flaxseed meal mixed with water.

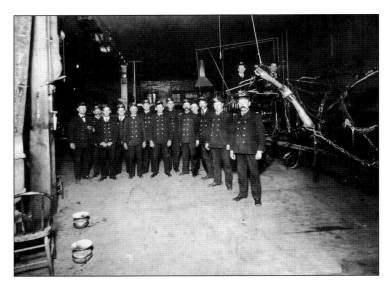

QUICK HARNESS. Trained to the sound of the fire bell, the fire horses lined up in front of their apparatus. A quick harness (on the right) was suspended from the ceiling, which was pulled down and the collars snapped closed. Before the bell quit ringing, the apparatus had usually already left the station.

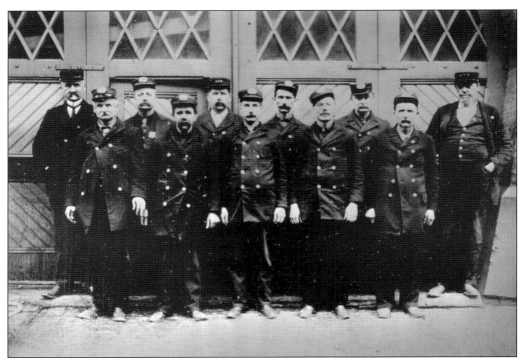

OLD HANDS. This photograph was taken in May 1896 in front of the Central Fire Station. From left to right are (first row) James "Doc" D. McMurtry, Timothy Maher, John "Jack" P. Slavin, Edward Thompson and Francis M. Bonnell; (second row) Chief George W. Muir, William Lanckart, James B. Gilroy, Daniel "Dee" Swope, Asst. Chief Frank M. Sutton and engineer William A. Metcalf. The roster had expanded to 13 men.

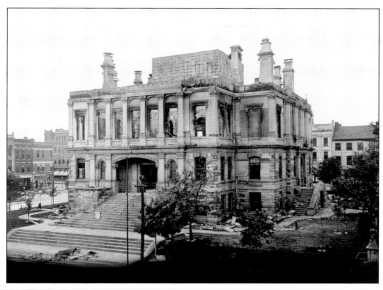

COURTHOUSE FIRE. On May 14, 1897, at 9:45 a.m., an employee climbing the courthouse's belfry to wind the clock dropped a match while lighting a cigarette. The wooden dome caught fire, which spread to the rest of the building. The fire department quickly arrived, but high winds and low water pressure prevented them from fighting the fire on the upper floors.

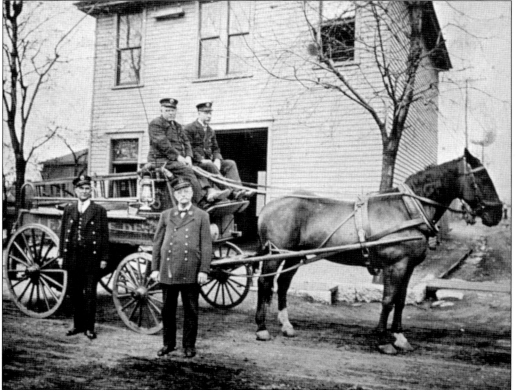

SUBURBAN REEL HOUSES. In 1898, the city opened Reel House No. 3 on Pine Street to protect the tobacco warehouse district on the south side. The fire crew members are, from left to right, (seated) David J. Reagan and Patrick Shannon and (standing) Frank M. Taylor and Capt. William Lanckart. Another reel house was on the east side of Woodard (later Maple) Avenue, just below Fifth Street, to cover the north side.

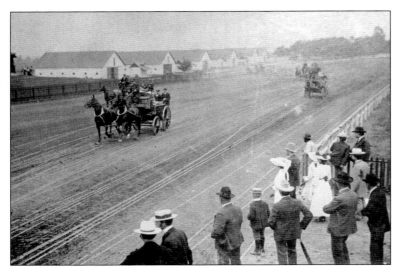

CHARITY RACE. In 1899, the hose wagons competed in a charity race at the Fairgrounds (later Red Mile) on South Broadway. As long as the race had no purse, betting on exhibition or charity races was legal. A portion of the betting pool was donated to the Firemen's Pension Fund.

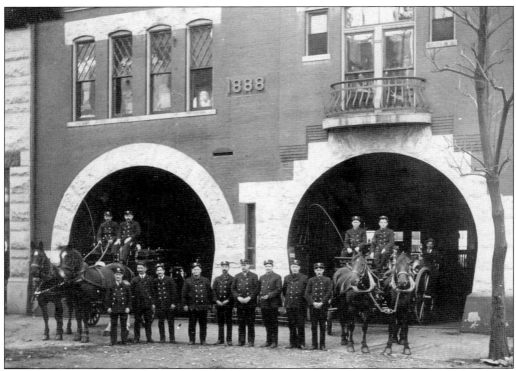

FIRE DEPARTMENT, C. 1901. The department roster still consisted of 13 firefighters around 1901. The *Hook & Ladder* wagon is on the left, and the chemical engine is on the right. Not shown is the old M.C. *Johnson* steam engine, two hose wagons, and the chief's buggy. Two additional hose wagons were stationed at the reel houses. (Courtesy of LFD.)

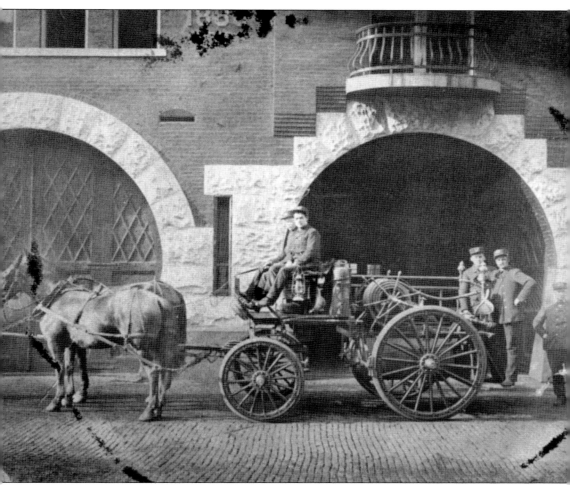

CHEMICAL ENGINE. In January 1901, a new chemical fire engine built by the Fire Extinguisher Company of Chicago arrived at the cost of $1,400. The engine was placed at the Central Fire Station, where a crowd of citizens inspected the latest in firefighting equipment. The new engine was tested behind the old auditorium on East Main Street, making quick work of a large pile of wooden dry goods boxes filled with straw and soaked in coal oil, then set on fire. The wagon contained a large hose reel and a 100-gallon chemical tank between the rear wheels. The tank held a mixture of water and 42 gallons of soda. After arriving at a fire, 40 gallons of acid were mixed to pressurize the tank. The chemical engine was intended for small fires or to quench a fire before it gained headway, before the hoses were attached to hydrants. Each charge would last 60 minutes at a cost of about $1.90.

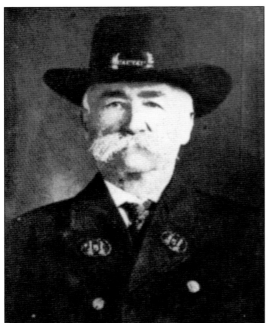

Chief Muir. George W. Muir was appointed fire chief in 1887, the first chief selected by the nonpartisan police and fire commission. He oversaw the expansion of the department to include two suburban reel houses. He resigned in 1904 but later became the Woodland Firehouse captain and first city building inspector. During the Civil War, he served under Confederate general John Hunt Morgan. (Courtesy of LFD.)

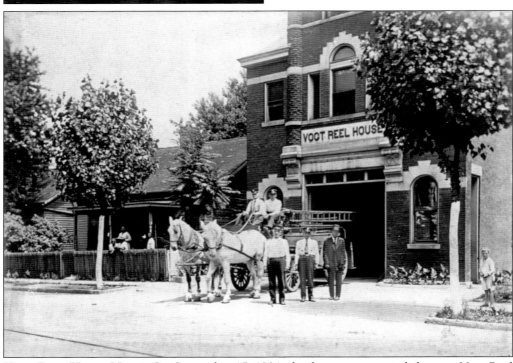

Vogt Reel House No. 4. On September 15, 1904, the fire crew occupied the new Vogt Reel House No. 4 on the east side of Jefferson Street between Second and Third Streets. The house covered the city's west end and responded to all alarms west of Broadway. The house was named after Henry Vogt, councilman and fire commissioner, who donated the land for the station. It is still in service today.

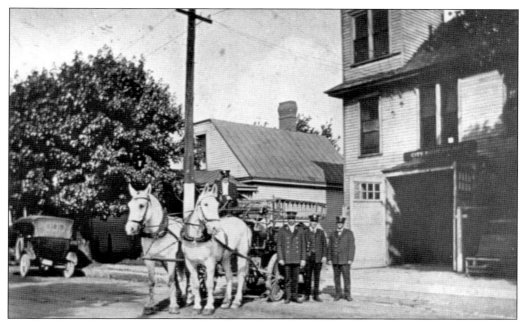

REEL HOUSE NO. 2. This station was on Woodard Street on the north end and equipped with a combination (hose and chemical) wagon with a three-man crew. Built to a similar design as Pine Street No. 3, the station has a central drive-through bay for the hose wagon and stables on the ground floor. The second floor contained the sleeping quarters and a three-story hose drying tower.

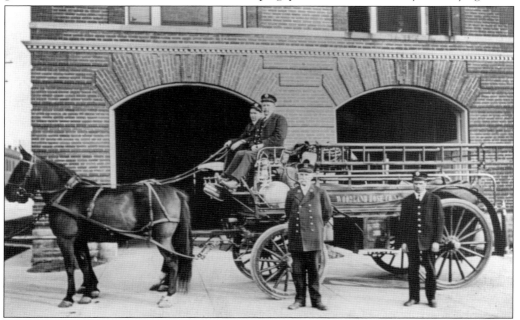

WOODLAND STATION NO. 5. Opened on the Fourth of July 1905, Woodland Station No. 5 was in the recently annexed Woodland subdivision, on Woodland Avenue at Maxwell Street. Standing are Capt. (ex-chief) George W. Muir (left) and Frank R. "Riley" Richmond. Seated are Bernard Murray (left) and James B. Gilroy. The station remains in use today.

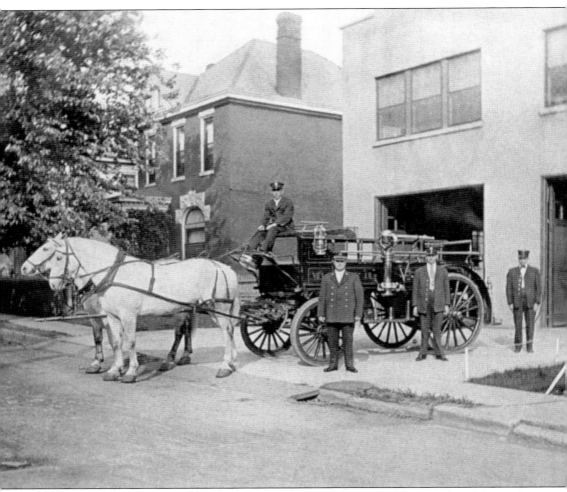

Last Run. The last horse-drawn fire wagon responded on July 26, 1926, from Merino Station No. 3 to a fire at Jersey and Winslow (Euclid) Streets. This wagon was retired on August 11, 1926, when a new motorized engine was placed in service at the station. The wagon's bed was installed on a 1926 REO truck chassis. The station today houses Rescue Company No. 1 and Emergency Care No. 10.

Two
Horseless Engines 1911–1914

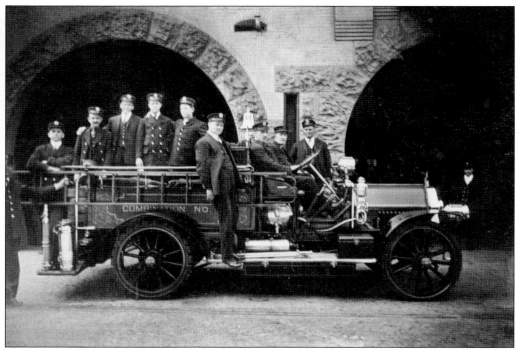

Horseless Fire Engine. The first motorized fire engine was purchased in July 1911 for $5,600 from the Knox Automobile Company of Springfield, Massachusetts. It was a combination hose and chemical engine equipped with a 43-horsepower engine capable of 35 miles per hour. It was thoroughly tested around town and climbed the hill on Broadway without any problems.

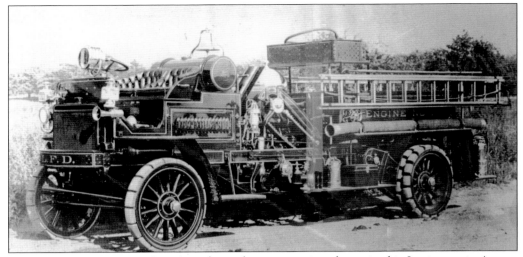

BUILDER'S PHOTOGRAPH, 1911. A triple combination engine also arrived in Lexington in August 1911 from the Knox Automobile Company. It was tested at the reservoir, where it pumped 150,000 gallons of water in three hours. The engine consumed 30 gallons of gasoline at a cost of $3.60 (12¢ per gallon). A steam engine would have consumed 3.5 tons of coal in the same time. (Courtesy of LFD.)

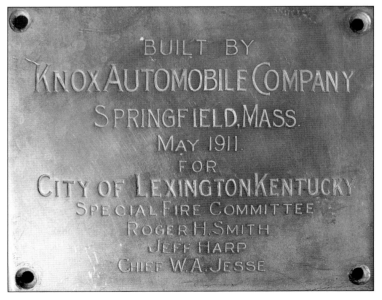

BUILDER'S PLATE, 1911. This brass builder's plate is from the 1911 Knox triple combination engine. The Knox Automobile Company built its first fire engine for its hometown, Springfield, Massachusetts, in 1906. The company ceased operations in 1927 after building 300 fire engines. The engine remains on the department's roster and is in storage. (Courtesy of LFD.)

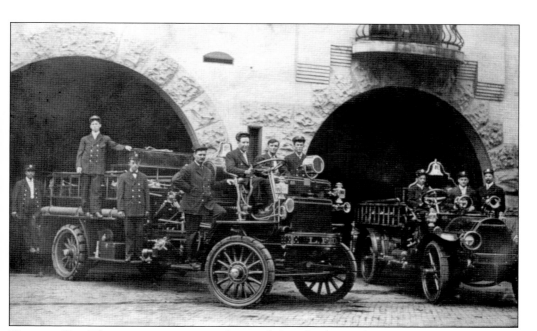

Hog and Pig. The new engines were nicknamed "Pig" for the combination engine with its long hood and "Hog" for the triple combination engine for its blunt nose. Both engines were painted bright red and equipped with a red light. Like horses, motorized fire engines were numbered, not named. (Courtesy of LFD.)

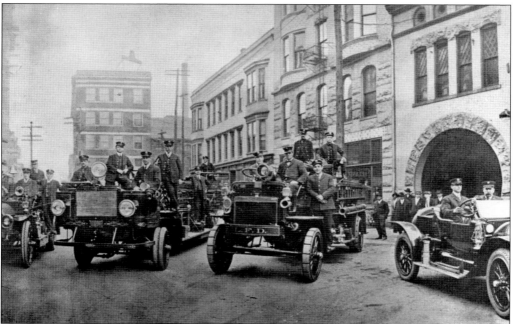

Auto Week, 1914. The department displayed fire apparatus in front of the Central Fire Station on West Short Street during Auto Week in March 1914. The fleet included (from left to right) the 1914 American LaFrance aerial, 1911 triple combination engine, and 1913 chief's Rambler motor car. The 1911 Knox combination engine is partly out of frame on the left.

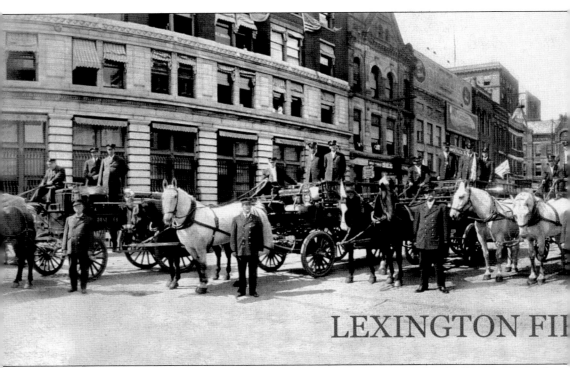

Apparatus Fleet, 1914. By 1914, the Central Fire Station was equipped with all motor-driven fire apparatuses. The fleet was photographed on Main Street in front of the courthouse in 1914. On the left are the horse-drawn hose wagons from the reel houses, with the 1914 American LaFrance aerial truck, 1911 Knox triple combination engine, 1911 Knox combination engine, and 1913

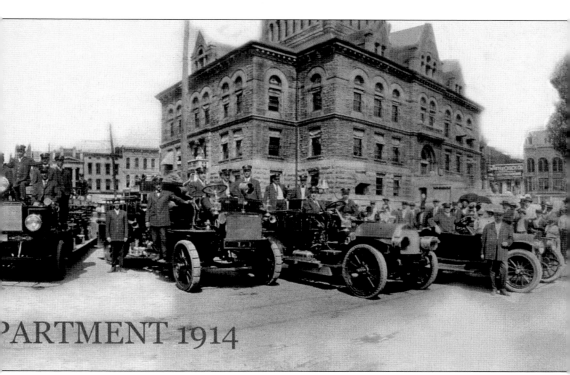

...PARTMENT 1914

chief's Rambler motor car on the right. The Central Fire Station's equipment costs were $27,700, while the reel houses were $7,500. The department employed 37 sworn firefighters paid $60 per month, while the chief made $150.

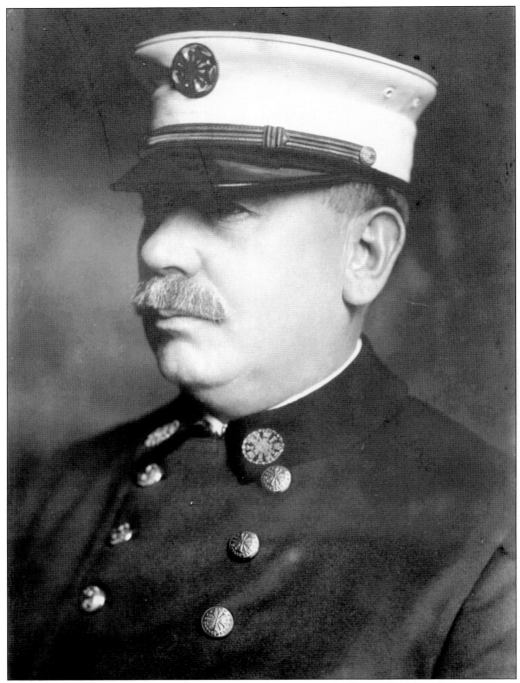

CHIEF JESSE. William A. Jesse was a mechanic and carriage maker with political connections. After serving three years as police chief of Lexington (1897–1900), he operated a grocery and beer distributor before becoming chief of the fire department in 1911. Under his direction, the department was motorized, and a platoon system was adopted with a day on and a day off rotation. He retired in 1928.

Three
WARS AND DEPRESSION 1914–1945

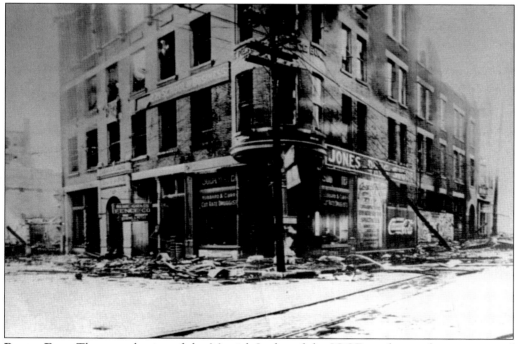

BLOCK FIRE. The gutted ruins of the Merrick Lodge of the IOOF on the northwest corner of Limestone and Short Streets are seen here after a block fire on May 21, 1917. The fire swept the block bounded by Church, Short, Upper, and Limestone Streets. The loss was estimated at $500,000. Flying sparks set the Second Presbyterian Church on fire two blocks away.

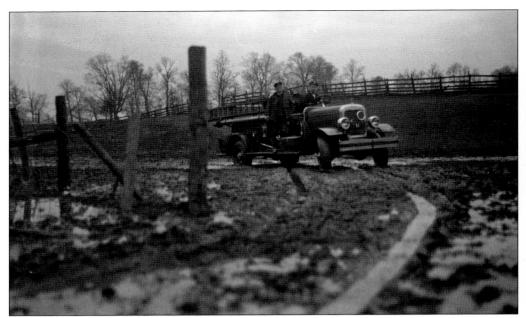

MUDDY ROADS. The early highways were the first to be paved during the 1910s. The surrounding county roads remained unpaved until the 1920s. Frequently, when dispatched to fires in the surrounding county, fire engines had to cope with mud, but enterprising firemen became experts operating in these conditions.

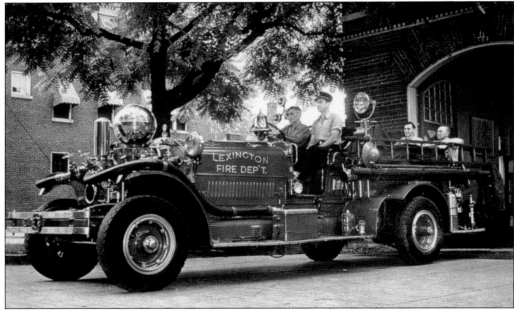

AHRENS-FOX PUMPER. The iconic pumper built by the Ahrens-Fox Company of Cincinnati, considered by many the Rolls Royce of fire engines, was delivered during 1917. The chain-driven engine was powered by a six-cylinder gasoline motor with artillery-style solid rubber wheels. During the 1930s, the pneumatic tires seen here were installed on the engine. The engine was retired after 1948.

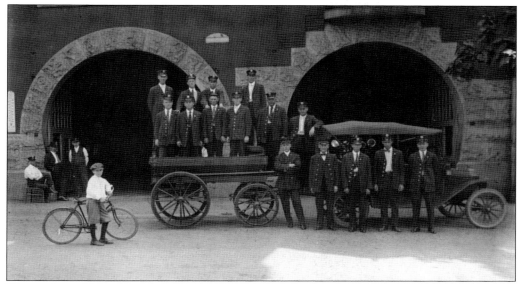

WHEAT CROP. These firemen volunteered to help harvest the wheat crop in the fall of 1918 during World War I. Firemen were exempt from the draft as an essential occupation. Off-duty firefighters spent September and October cutting wheat, which was milled into flour at the Lexington Roller Mills on Broadway. (Courtesy of UK.)

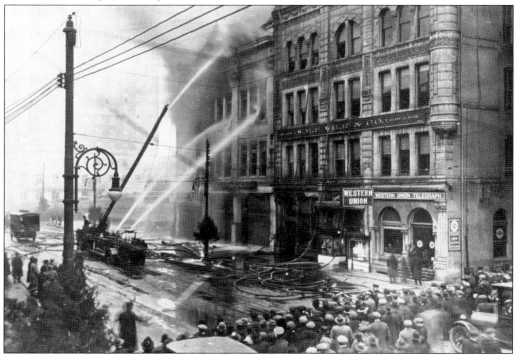

DEPARTMENT STORE FIRE. In January 1921, the Kaufman Clothing and Wolf Wiles stores on Main Street were destroyed by fire. The fire raged for over four hours despite the entire Lexington Fire Department's efforts. A reel house manned the Central Station in case of another fire. The adjacent J.D. Purcell Department Store was also damaged.

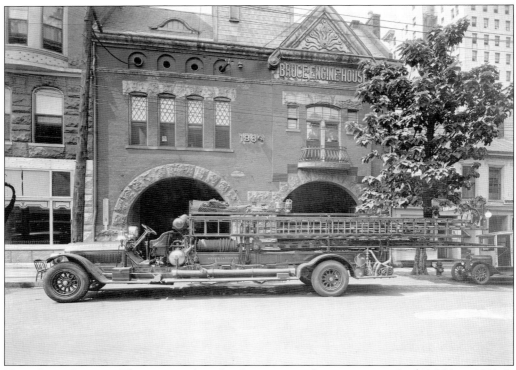

NEW QUAD LADDER. The city purchased a Seagrave quad rotary engine for $11,000 in 1922. It was a 600 gallon-per-minute pumper with a 40-gallon chemical engine and a booster tank, and ground ladders. The engine was assigned to the Central Station as Hook & Ladder Company No. 2 for years and then at the Woodland Station. It was scrapped in 1953.

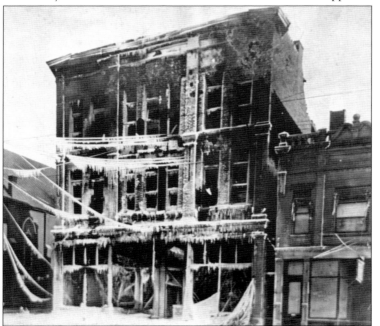

CANDY FACTORY. An early morning fire in November 1924 caused estimated damages of $40,000 to the So-Good Candy Factory on Vine and Spring Streets. The fire department limited the fire to the third floor, but water damages to the lower floor ruined the stocks of sugar and other ingredients. The sticky mess was cleaned up in two weeks, and the factory resumed operations for the Christmas season.

HOOK & TURRET TRUCK. The department built a hook & turret engine from an REO truck chassis and the bed of an old Seagrave hose wagon in 1926. It was stationed at the Central Fire Station to supplement the existing pumpers. The engine was also equipped with three spotlights to illuminate a fire.

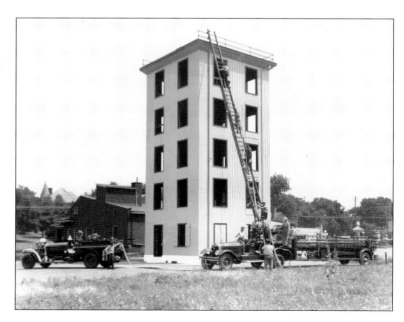

TRAINING TOWER. The department built a five-story training tower in October 1926 behind Station No. 6 on South Broadway for $3,500. J. Evans Berryman was hired as the training instructor, with each station trained in rotation periodically. The 1926 Ahrens-Fox pumper and 1929 American LaFrance ladder trucks are seen at the tower in the late 1930s.

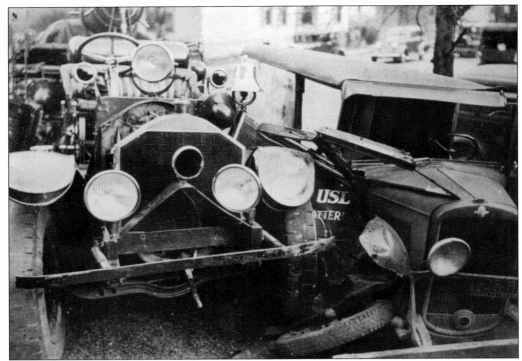

Wreck. While on a practice run in May 1928, the 1922 Seagrave quad truck struck a parked automobile on Limestone. The driver and her infant son had just left the parked car at the time. The sedan was brand new and a total loss. Repair of the damages was estimated at $1,000.

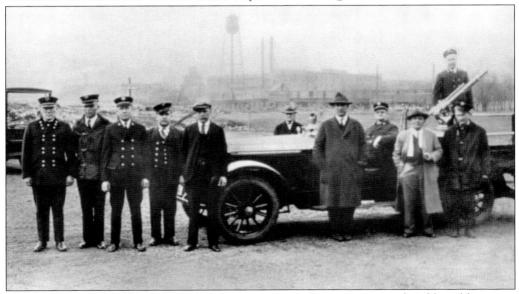

Touring Car. City officials inspected the turret nozzle fire apparatus at the old workhouse on Upper Street in 1928. The apparatus was an old Duryea touring car with a turret installed in the back at a cost of $250. The officials were impressed, especially by the price, while the fire department quietly placed Turret Nozzle Car No. 1 in reserve before discarding it a few years later.

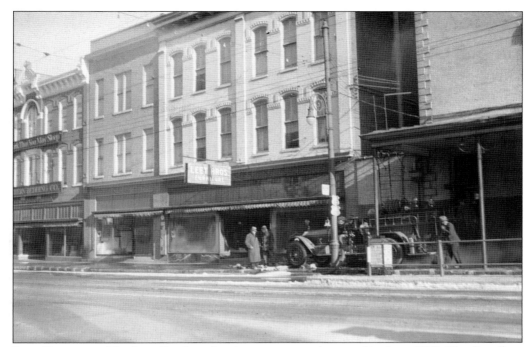

LEET BROTHERS. The Leet Brothers furniture store was destroyed in June 1929. The first floor of the store on Main Street, west of Broadway, was gutted by flames during an afternoon blaze. The fire was quickly brought under control, but smoke damaged the upper floors. This block was developed in the 1980s into Victorian Square.

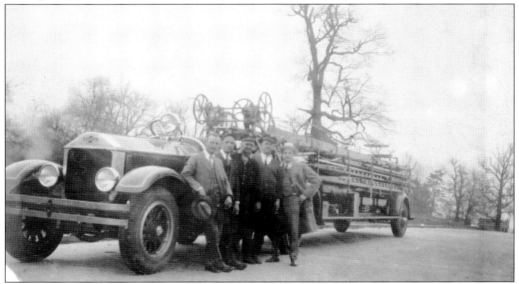

REPLACEMENT LADDER TRUCK. In May 1929, the department received a new $16,500 tractor/trailer aerial ladder built by American LaFrance with a 75-foot ladder. The tractor was an open cab with a 105-horsepower engine and chain drive. The ladder wagon had a rear tiller to navigate tight corners. The tractor was replaced in 1951 with a Diamond T tractor. The unit was removed from service in 1966 and remains in storage. (Courtesy of LFD.)

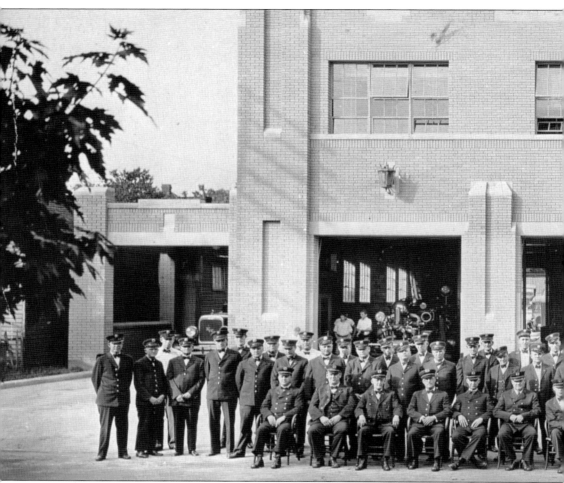

CENTRAL FIRE STATION, 1929. At 10:00 in the morning on June 7, 1929, the fire bell at the Central Fire Station on Short Street rang for the last time. With the ringing of the bell, the fire engines paraded to the new station on East Third Street near Walnut (now Martin Luther King). The new station was built by the Perry Lumber Company for $32,000. The site had been selected

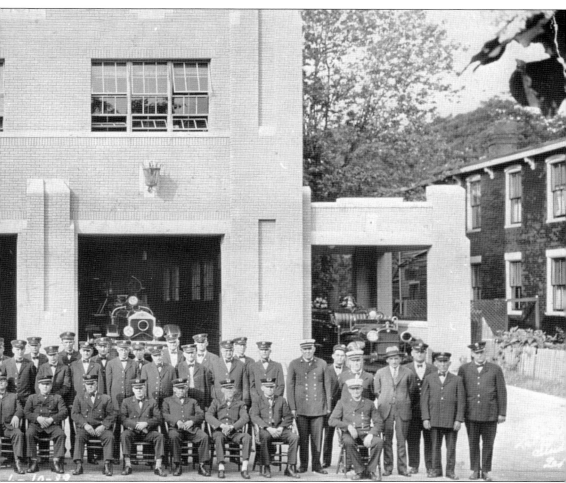

to remove the station from the congested downtown business district. During the last year, two fire engines had been involved in wrecks due to the traffic. The old station on Short Street was sold at a public auction and became an REO automobile dealership.

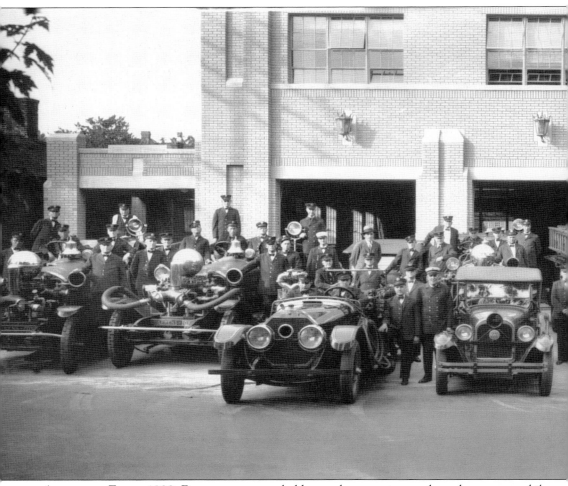

Apparatus Fleet, 1929. Five pumpers, two ladder trucks, a service truck, and two automobiles comprised the department's fleet, as shown during the dedication of the new Central Fire Station in June 1929. Chief Bruno F. Shely and his crew lined up in front of the new station in their class A uniforms. The second floor contained the barrack-room, bath facilities, and private bedrooms

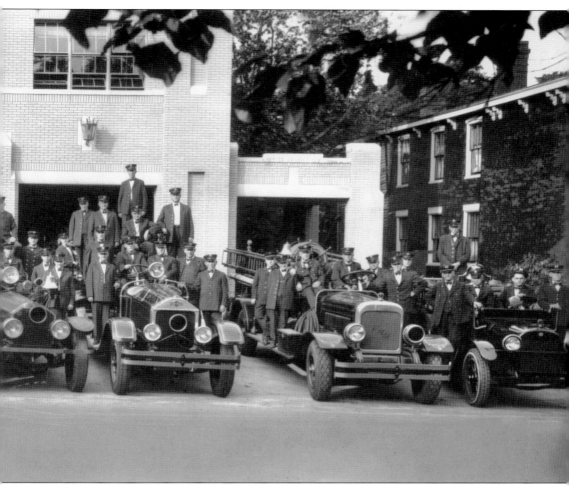

for the chief and his assistant chief. The old 1911 Knox pumper was rebuilt by students at the University of Kentucky's College of Engineering and placed in reserve status at the station after the dedication. With the Great Depression during the 1930s, this was the last fire station built in Lexington until 1962.

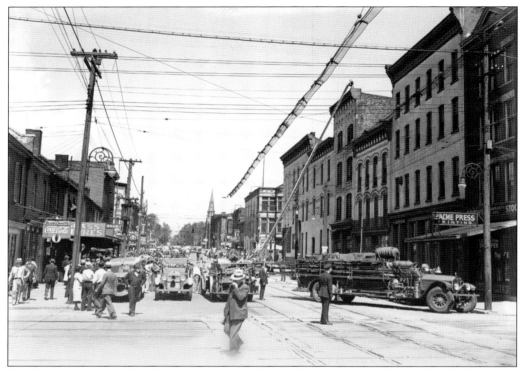

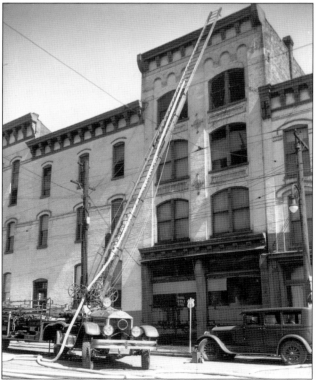

BROADWAY FIRE. The Southern Bedding Company on South Broadway between Main and Water Streets was gutted by fire in the early 1930s. The entire department was called out for the fire, with one company stationed from one of the reel houses to the Central Station in case of another fire. The fire was quickly brought under control, but the bedding material continued to smolder.

AERIAL LADDER. The 1929 American LaFrance ladder truck was deployed at the Southern Bedding fire. It was used to place firefighters on the roof of the building to fight the blaze and ventilate the smoke. The ladder was without a pump, so it was connected to a pumper or fire hydrant.

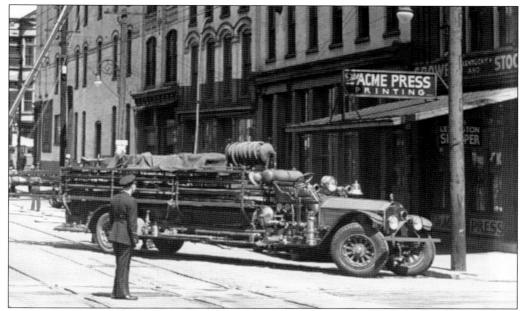

SEAGRAVE LADDER, 1922. The quad truck is attached to the fire hydrant at the corner of Broadway and Water Street to supply water to the aerial truck. The quad truck boosted the water pressure using its rotary pump to supply the aerial ladder. A quad ladder truck had four functions: a pumper, a booster tank, hoses, and ground ladders.

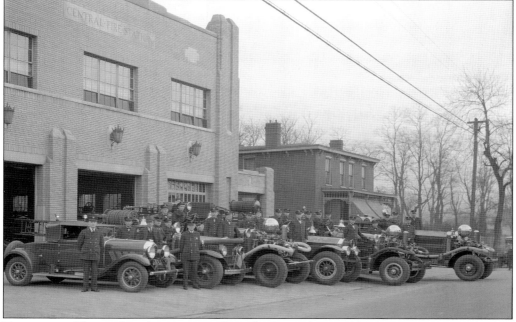

FLEET, 1931. The modern fire apparatus from the Central Station line up in December 1931 for a promotional photograph. The fleet included the chief's car, four pumpers (three of which were Ahrens-Foxes), and the aerial ladder. With the economic conditions, only one new unit was purchased in 1939 until after World War II. (Courtesy of UK.)

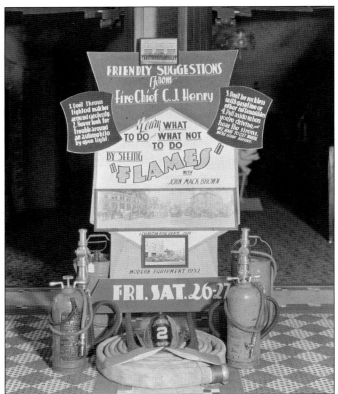

Movie Premiere. In August 1932, at the premiere of the movie *Flames* at the State Theater, Chief C.J. Henry gave a presentation on fire prevention. His suggestions were "don't throw lighted matches around carelessly, never look for trouble around an automobile by open light, don't be careless with gasoline or other inflammables and pull aside when you hear the sirens." (Courtesy of UK.)

Hook & Ladder. Students at Maxwell Elementary built a ladder truck as part of their studies in the early 1930s. Later, they visited Woodland Station No. 5 across the street to inspect the actual engine. Their fire truck does not appear on the official roster. (Courtesy of UK.)

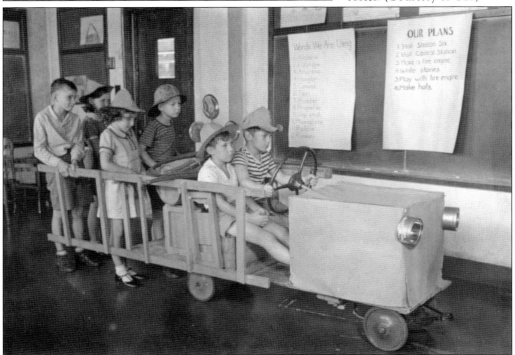

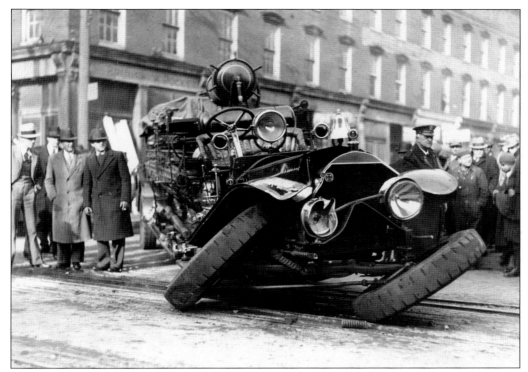

Locomotive vs. Ladder Truck. The 1922 quad truck was responding to an alarm on January 31, 1934, when it collided with a passenger locomotive at the railroad crossing at Mill and Water Streets. The driver was thrown onto the railroad tracks but pulled to safety by another fireman just before the locomotive passed. The front axle of the ladder truck was broken in the accident.

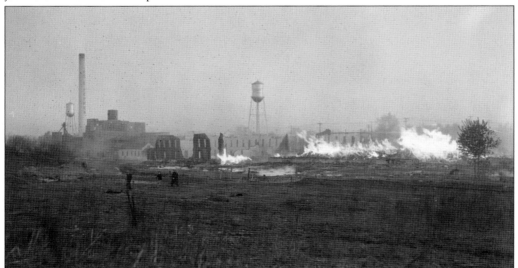

Distillery Fire. During the night of April 28, 1934, an accidental fire consumed six warehouses and the bottling plant at the James E. Pepper Distillery on Frankfort Pike. The loss was estimated at $5 million, including 15,000 barrels and 11,000 cases of bourbon. The flames were visible as far as Versailles and Frankfort. This was the largest monetary loss suffered in Lexington. (Courtesy of UK.)

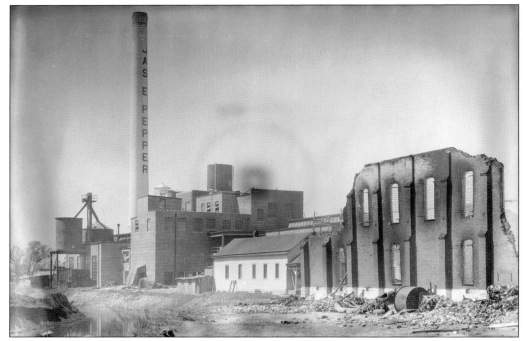

DISTILLERY RUINS. The Pepper distillery plant in the background remained undamaged, but six wooden warehouses were destroyed by fire in April 1934. The plant was just completed with the repeal of Prohibition the prior year. The police had trouble controlling the crowd, with volunteers trying to save cases of bourbon. (Courtesy of UK.)

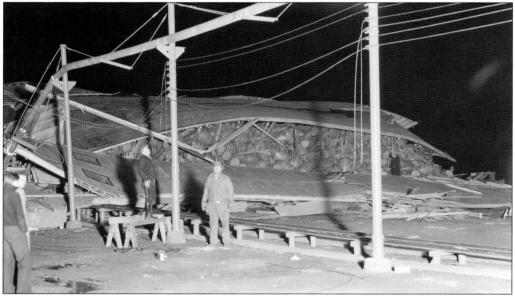

WAREHOUSE COLLAPSE. In December 1934, one of the replacement warehouses at the Pepper Distillery on Old Frankfort Pike collapsed. The fire department rushed to the site and ordered the power cut off, fearing a repeat of the fire in May. The distillery placed guards around the whiskey-soaked mass to prevent samples being taken. (Courtesy of UK.)

HOTEL FIRE. The upper floor of the Leland Hotel on Limestone and Short Streets was slightly damaged by fire in January 1937. The damage was contained to several rooms on the upper floor. The old Central Fire Station with its distinctive bell tower, by then an REO car dealership, is next to the hotel.

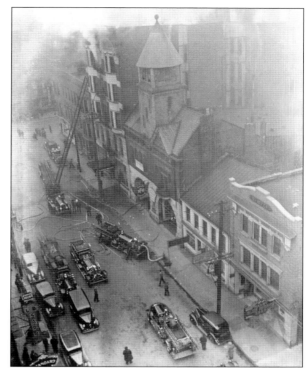

GROCERY FIRE. Ignited by a blow torch used by painters, a fire fed by a strong wind swept through the Chesapeake & Ohio Railroad warehouse on Water Street in May 1937. The Lexington Grocery Company leased the east end of the warehouse. The department deployed 10 hose lines fighting the fire. Damages were estimated at $150,000.

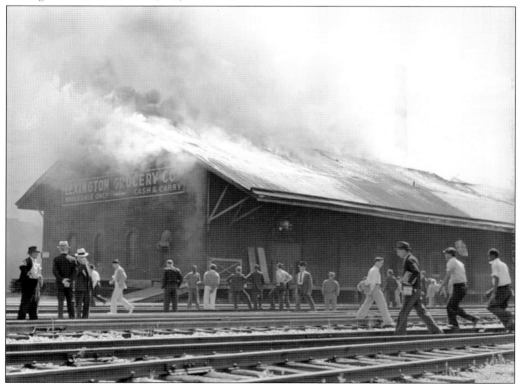

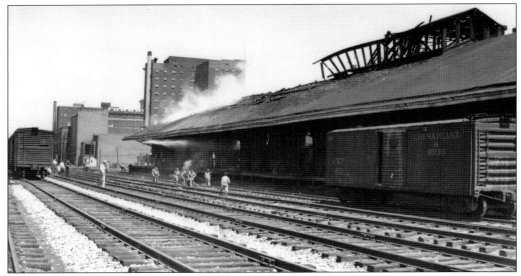

WAREHOUSE FIRE. The fire at the Chesapeake & Ohio warehouse was still smoldering in May 1937. The fire caused the roof to collapse on stacks of hundreds of cans of food. The railroad tracks are along Water Street, between Main and Vine Streets, with the Phoenix and Lafayette Hotels in the background.

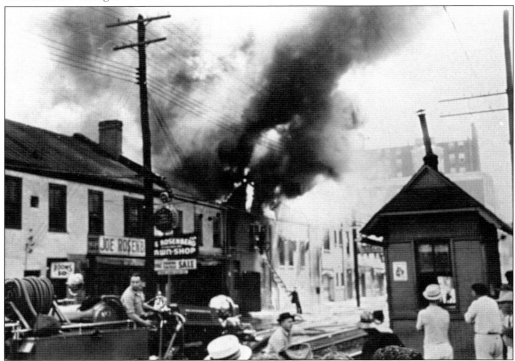

VINE STREET. The Lexington Fire Department battles a warehouse blaze on Vine Street during the late 1930s. Vine Street was lined with old wooden warehouses, many built before the Civil War, along the railroad tracks. They were prone to fires that could quickly consume the building. The fire department here is working to prevent the fire from spreading to adjacent warehouses.

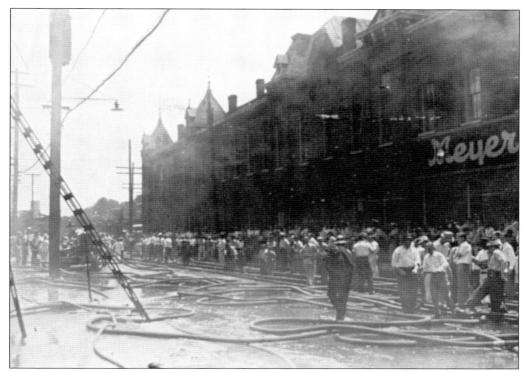

Spectators. A large crowd lines the sidewalk to watch the excitement at the Vine Street fire in the 1930s. The police department was often deployed to control these crowds, which numbered into the hundreds. After the railroad tracks were removed in 1968, the entire district was razed in an urban renewal project.

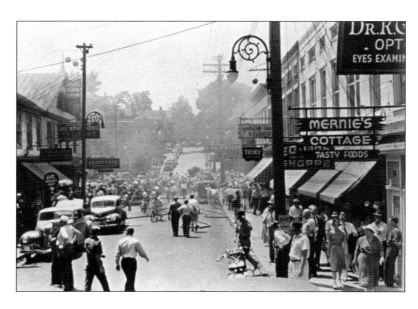

Onlookers. A large crowd gathers at another fire at the corner of Mill and Vine Streets in the late 1930s. In 1933, the department responded to over 900 alarms but with a total loss of only $79,521. Eighty-three men were employed by the department. Note the ornamental coiled street light.

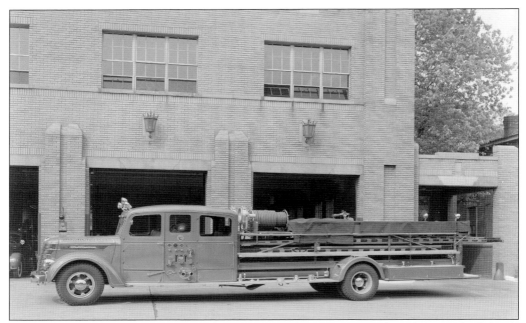

Quad Engine, 1939. An International Harvester quad engine was purchased in 1939 for $10,910. The engine was a combination pumper, hose, booster, and ladder truck. It featured a four-door enclosed cab, known as a front rig, with a capacity of 750 gallons per minute. The unit was retired in 1964 after the Vaughn Tobacco Warehouse fire. (Courtesy of UK.)

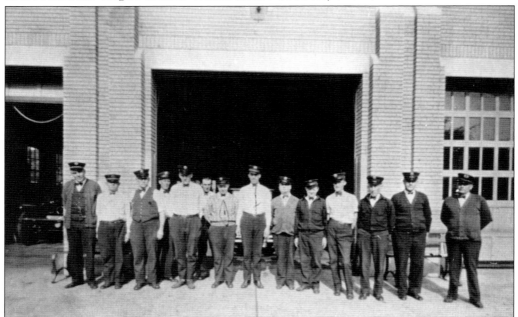

Fire Crew. The day shift at the Central Station poses for a photograph during the late 1930s. These men were eligible for half-pay pensions after 20 years or disability. Widows of firefighters who died in the line of duty received their husband's pension. The pension fund was funded by a tax of 2¢ per $100 assessed value.

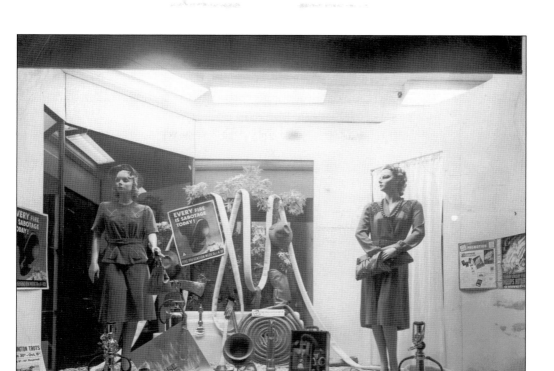

WOMEN AT WAR. Fire Prevention Week during November 1942 assumed a new meaning with the country at war. The display in the Purcell Department Store's front window highlighted women's increasing role on the home front. Firefighters were exempt from the draft. The first female firefighter was not hired for almost 40 years.

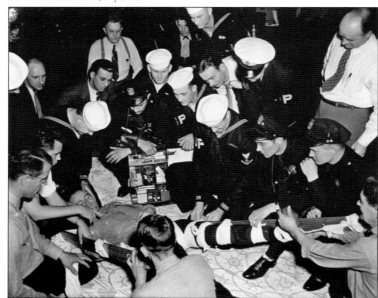

SHORE PATROL. The department provided first aid training to the US Navy Shore Patrol in Lexington during 1944. Portions of the University of Kentucky campus were used for training military personnel during World War II. The department also assumed civil defense training, which continued until the close of the Cold War.

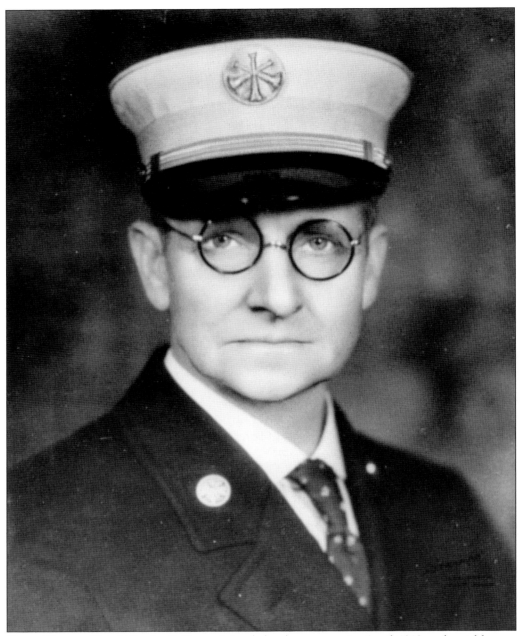

CHIEF HENRY. Chief Charles J. Henry joined the department in April 1912 and quickly rose through the ranks. He was appointed chief in November 1930 at the start of the Great Depression. At one point, the firemen went unpaid for several months until the city collected tax revenues. Chief Henry died in February 1944.

Four
Postwar Era
1946–1973

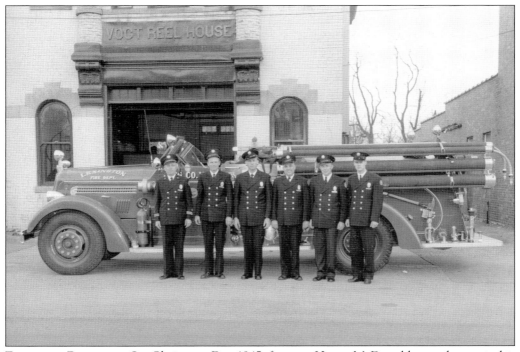

FIREHOUSE PHANTOM. On Christmas Day 1945, fireman Henry McDonald passed away in his sleep at the Vogt Firehouse No. 4. He was 69 years old, still in service because of World War II. Strange occurrences have been noted ever since, including ghostly heavy boot sounds on the cast-iron spiral stairway and cold, mysterious breezes.

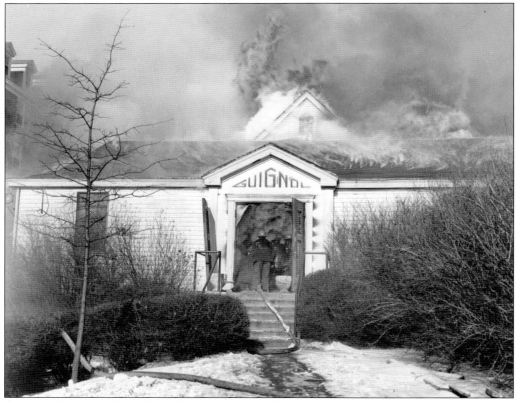

GUIGNOL THEATER. The Guignol Theater on Walnut (now Martin Luther King Boulevard) at Euclid Avenue was destroyed by fire on February 11, 1947. Named after the famous Grand Guignol Theatre in Paris, France, the theater was built on the University of Kentucky campus in 1927. It was recognized for the plays presented by the theater department during the Great Depression.

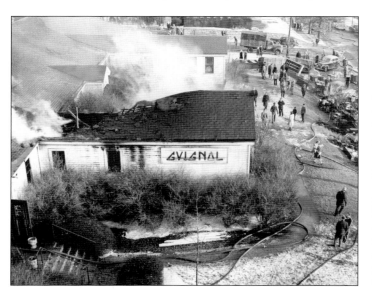

CURTAIN CALL. The theater's manager said that the Guignol "went up like matchwood" in February 1947. The department quickly arrived at the site, but given the wooden construction, the fire had spread to the rest of the theater. Students removed the piano and other instruments from the musical department before the fire consumed them.

Final Act. The Guignol Theater was engulfed in flames as the entire building was destroyed in February 1947. The adjacent Jewell and Boyd dormitories were also damaged by smoke, and the sprinklers on the fourth floor of Jewell were set off by the heat. Three years later, the Guignol reopened in the Fine Arts Building on Rose Street.

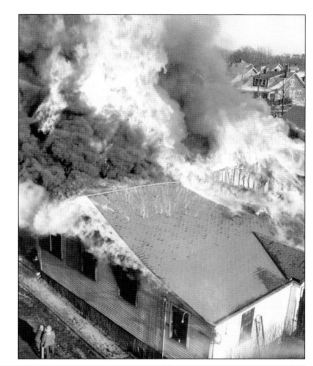

Fog Nozzle Test. Firefighters test a new fog nozzle in May 1947 to fight indoor fires with a diffusion of water. Charles Reid and Capt. G.C. Corman man the nozzle, while Capt. W.L. Blythe, drillmaster, looks on. The fireman to the right is unidentified. The department's engines were equipped with these new nozzles.

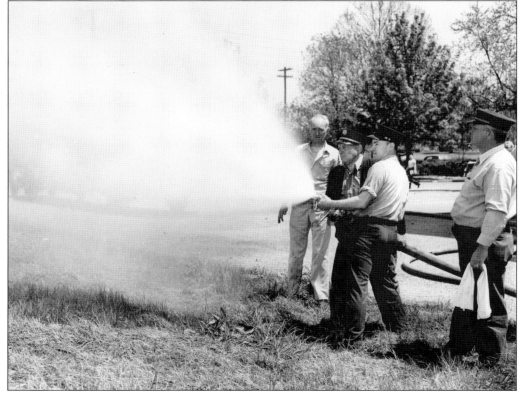

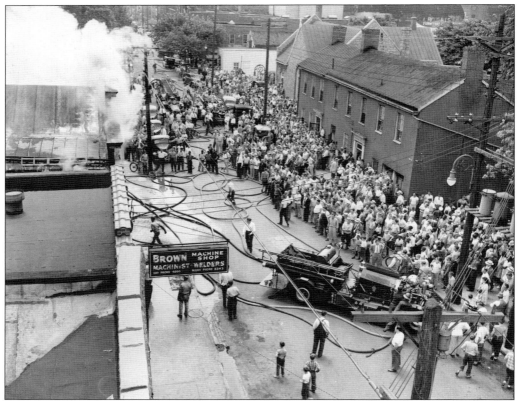

HUNDREDS ATTRACTED. Clouds of smoke billowed into the sky in July 1947, attracting hundreds to the fire that destroyed the Dixie Insulation Company's warehouse at 539 West Short Street. Firefighters spent more than two hours pouring streams of water on the flames before the blaze was brought under control. The loss was estimated at $100,000.

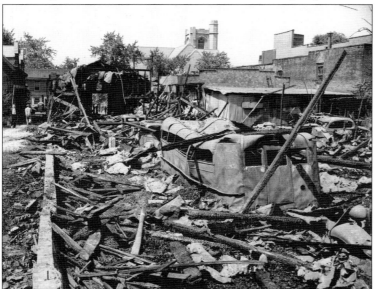

DESTROYED. The fire at Dixie Insulation completely destroyed the warehouse and contents during July 1947. The warehouse contained thousands of bags of insulation wood, resulting in billowing black clouds of smoke visible as far as Versailles and Frankfort. The fire was out of control by the time firemen arrived at the site.

Feed Mill. The Sun-Ray Feed Mills nighttime fire on Henry Street gutted the five-story building with only a tottering brick wall, with "Lexington, Kentucky," remaining. The company was a subsidiary of Woolcott Flour Mill Company. After four hours, the fire was finally brought under control. The damage was estimated at $250,000 in the November 1947 fire.

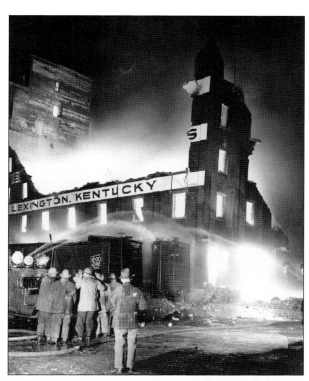

Mill Fire. Extreme heat and collapsing walls hampered the firefighters battling the blaze at Sun-Ray Feed Mills. The building was a total loss, with the remaining walls demolished shortly afterward. The company manufactured Sun-Ray mash for chicken and horse feed.

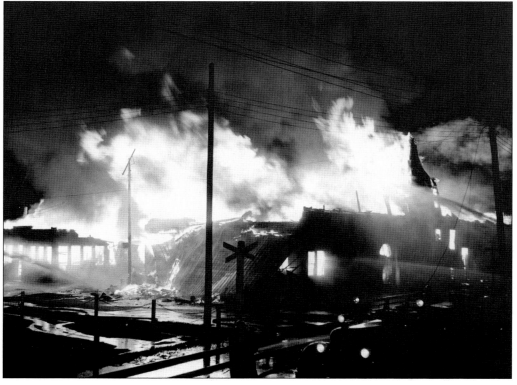

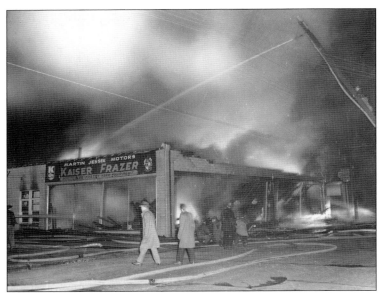

The $100,000 Fire. Firefighters pour streams of water into the Martin Jesse Motor Company's burning showroom at 328 East Vine Street, damaged in an early morning blaze in December 1947. Firefighters managed to confine the flames to the front of the structure, saving all but 7 of the 35 new $2,500 Packard automobiles stored in the garage's rear. The damage was estimated to be about $100,000.

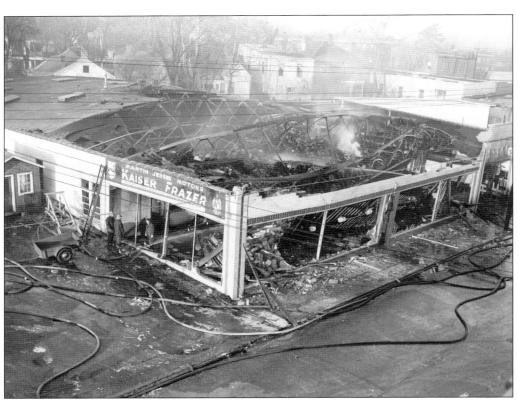

Stubborn Flames. On December 17, 1947, an early morning fire left the Martin Jesse Motor Company on Vine Street in shambles. Seven fire companies responded to the four-alarm blaze. The building was still smoldering eight hours after the fire, with a pumper stationed through the next day. The company reopened three days later.

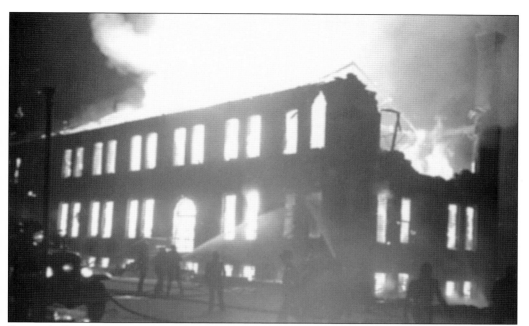

SCHOOL'S OUT. In January 1947, the old Douglas School on Georgetown Street was destroyed by fire. The school was a segregated school operated by the Fayette County Public Schools. By the time the county fire department had reached the scene, the building was fully engulfed and a total loss. The county fire department maintained its station under the West Main Street Viaduct.

UNIVERSITY FIREHOUSE. Station No. 6 was named the Scovell Engine House after Melville A. Scovell, a prominent agricultural researcher at the Agricultural Experimental Station. The firehouse opened in 1916 on Limestone near the University of Kentucky. This image is from the early 1950s, with a 1948 Seagrave fire engine in front of the station and the training tower. (Courtesy of LFD.)

Toy Drive. Fireman W.T. Kerns is repairing toys for the annual Boy Scouts Toy Drive in December 1948. Firefighters at the Central Station devoted their off-duty hours to repairing and repainting old toys collected from the community. In 1930, the first toy drive was organized for the orphans of the city. This tradition continues with the annual Lexington Fraternal Order of Firefighters Toy Program.

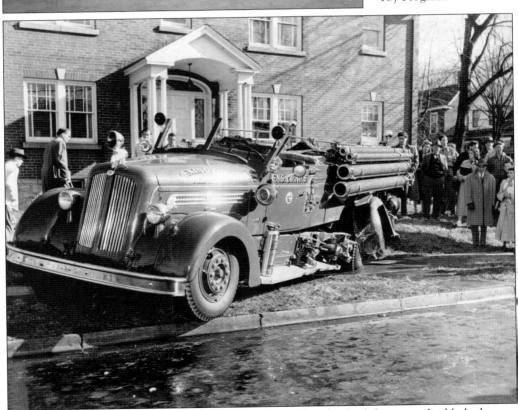

Wreck. In November 1949, Engine No. 6 was damaged and a firefighter was disabled when an automobile crashed into the rear of the engine at the intersection of Rose Street and Euclid Avenue (pictured). Five months later, the same engine hit a car at the same intersection. The driver of the vehicle was killed after he failed to hear the siren. The three firemen aboard the engine were uninjured.

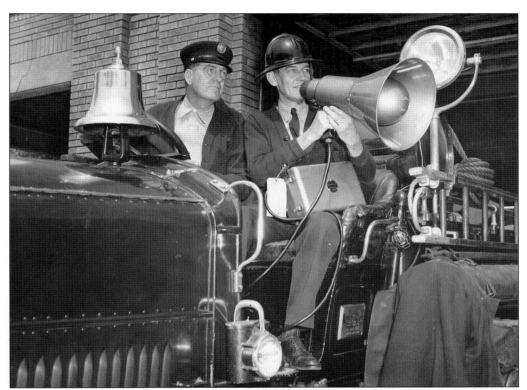

Can You Hear Me Now? Two unidentified firemen test out the new Guidnel bullhorn at the Central Station during the late 1940s. At over 35 pounds, announcements were kept short. The department also began installing two-way radios on all fire engines to improve communications for units responding to fires.

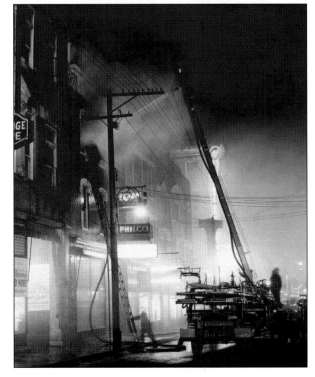

Store Fire. The third floor of Fayette Furniture on North Limestone was entirely engulfed by flames in February 1951 by the time the first units arrived. Four additional companies were dispatched to the fire. The fire was extinguished after a two-hour battle, with $60,000 in losses mainly from smoke and water damage to the store's inventory.

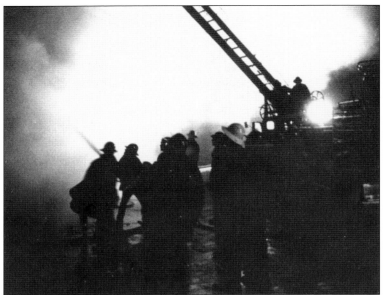

HEAVY SMOKE. Heavy smoke hampered the firemen fighting the Fayette Furniture blaze until several men were placed on the roof of the three-story building using the aerial ladder. After cutting holes in the roof, they ventilated the smoke and poured water onto the flames. The fire was confined to the third story, but four other buildings received smoke damage.

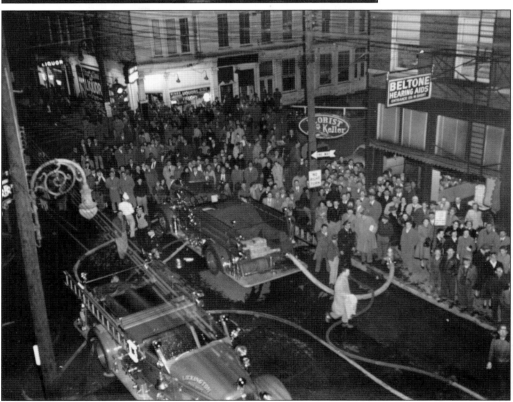

LARGE CROWD. Hundreds gathered to watch the department fighting the Fayette Furniture fire at Short and Limestone Streets during February 1951. Unseasonably warm weather encouraged the spectators to remain long into the night. A fire engine remained on the site until the next afternoon to prevent a flare-up from hot spots.

OLD JOHNSON SCHOOL. The old Johnson School on Fourth Street at Limestone is almost entirely obscured by smoke in May 1951. The privately-owned building was extensively damaged while being renovated into apartments. The department used 184,000 gallons of water, and firemen drilled holes in the floors to drain water after the fire.

TOBACCO WAREHOUSE. The New Independent Tobacco Warehouse No. 3 at 544 Angliana Avenue burned in December 1951. The three-alarm fire was uncontrollable when the department arrived due to the wooden construction of tobacco warehouses. Chief Earl R. McDaniel indicated that the warehouse "went up in a column of smoke and fire" within minutes.

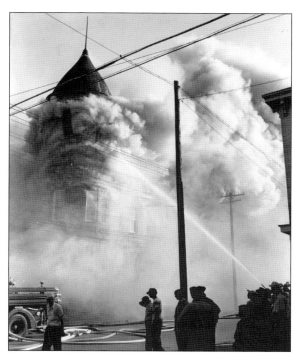

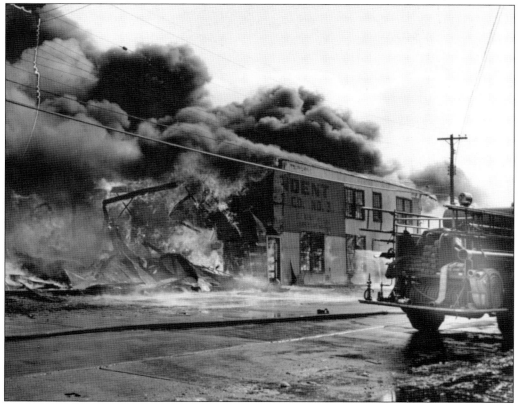

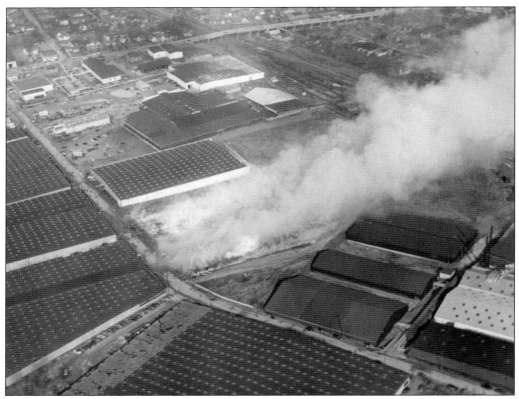

TOBACCO LOSS. A half-million dollars of Burley tobacco went up in flames when the New Independent Tobacco Warehouse No. 3 was destroyed. The warehouse on Angliana Avenue still smoldered the day after the fire in December 1951. Five pumpers, one combination engine, and a ladder truck were deployed. Twenty volunteers from the department's auxiliary, Box 212, assisted at the site.

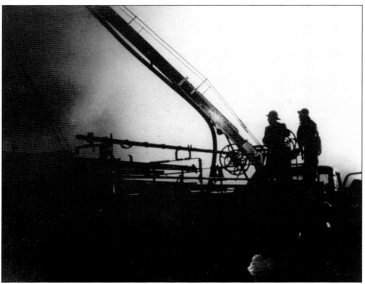

HAND WINCHES. The 1929 American LaFrance aerial ladder was spring-loaded, which raised the ladder to a certain level. Hand winches were used to extend the ladders to their full height. This was backbreaking work for the firefighter operating the winches. A fire hose was connected under the ladder to supply water.

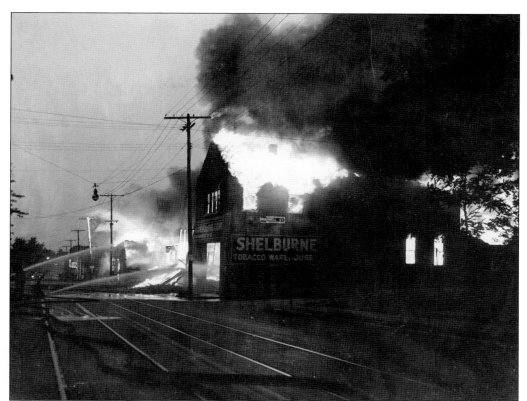

ANOTHER TOBACCO WAREHOUSE. In August 1953, an early morning fire destroyed the Shelburne Tobacco Warehouse on the corner of South Broadway and Pine Street. The fire was discovered by two patrolmen at 5:45 a.m., and by the time the department arrived, the outer walls had collapsed. The department prevented the fire from spreading to the adjoining warehouse. Estimated losses were $350,000.

CENTRAL TOBACCO DISTRICT. As the outer walls collapsed, the Shelburne Tobacco Warehouse's upper-story office succumbed to the fire in 1953. The warehouse only contained 400 hogsheads of tobacco but also had barrels of tar in storage. The tar barrels exploded, shooting flames hundreds of feet in the air.

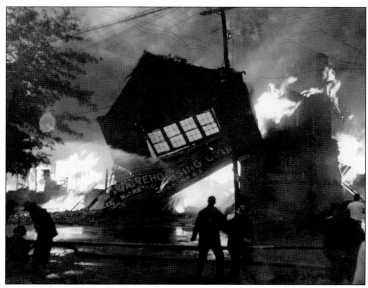

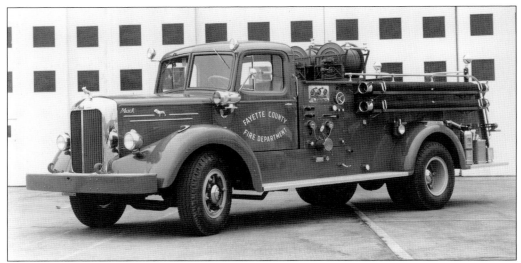

COUNTY FIRE DEPARTMENT. The county purchased a 1953 Mack pumper in May 1953 for $17,175 with a 750-gallon-per-minute pump and 800-gallon booster tank. By 1953, the population in the county was equal to the city. The budget for the city and county fire departments was $490,000 and $81,000, respectively. The city had 18 pieces of equipment, while the county only had six.

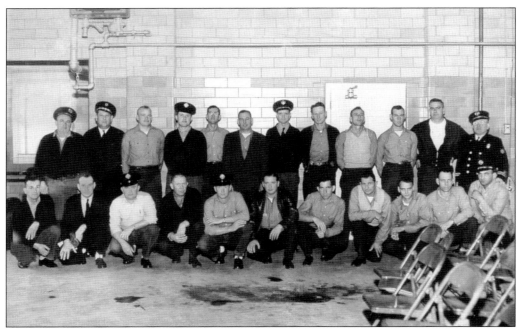

FAYETTE FIREMEN. The county had 28 firefighters in 1953, compared to 111 for the city. The disparity between the two departments continued until 1973, with the Lexington-Fayette Urban County Government's creation. After the merger, many of the less-trained county firefighters were dismissed, and most of the department's equipment was scrapped.

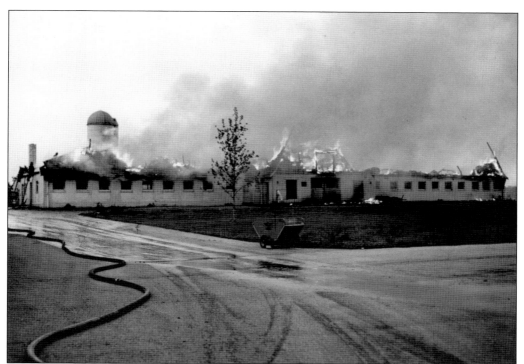

EXPERIMENTAL STATION FARM. The loft of the dairy barn at the university's Agricultural Experimental Station on South Limestone at Cooper Drive was destroyed in an early morning fire on May 25, 1953. The first floor was saved by a concrete ceiling. The farm was outside of the city limits at the time and is now the site of Commonwealth Stadium.

OLD WORKHORSE. Fireman T.F. Fitch operates one of the Ahrens-Fox engines at the reservoir after an overhaul around 1954. The city purchased three Ahrens-Foxes between 1917 and 1926. These engines were slowly replaced by new engines beginning in 1948. As newer engines were acquired, these were placed in reserve after a service life of 40 years.

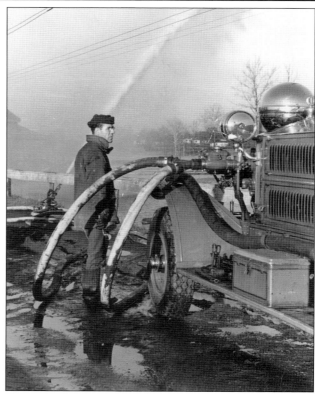

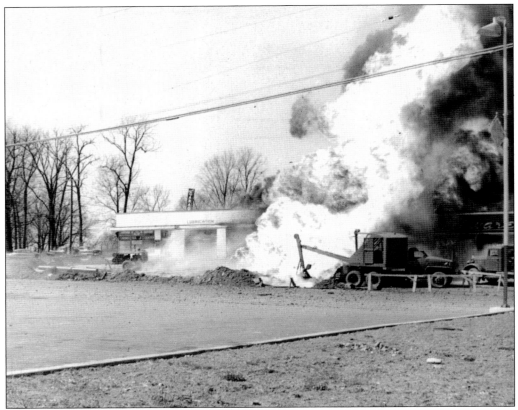

Gas Explosion. While replacing the natural gas line in March 1954, a massive explosion erupted in front of the Lafayette Shopping Center at Rosemont Gardens. The center was on Harrodsburg Road at Rosemont Garden, just outside of city limits. Both the city and county fire departments responded to the blast, which was heard for miles.

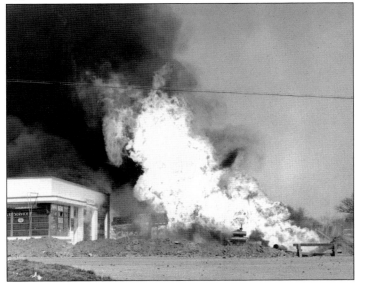

Shopping Center Explosion. The Lafayette Shopping Center was heavily damaged in March 1954 by the explosion of the gas lines in front. After the gas was cut off, the fire was brought under control. The intense heat from the flames damaged the service station on the other side of Harrodsburg Road. The damage was estimated at $300,000.

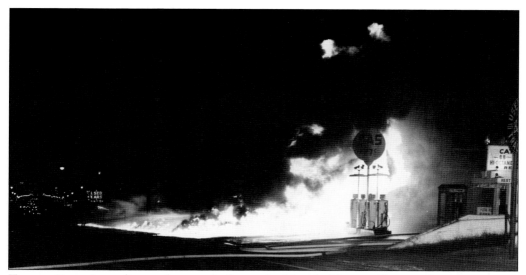

TANKER FIRE. A gasoline tanker caught fire at the Lincoln-Mercury Company's service station on East Main Street in September 1955. The blast was heard as far as a mile away, while flaming gasoline flowed down the gutter toward downtown as far as Midland Avenue. Two companies responded to the alarm but were unable to bring the flames under control until most of the gasoline had burned off.

WHAT FIRE? GAS 27¢! Burning gasoline flowed down East Main Street at the tanker fire in September 1955. Auxiliary fireman Col. John L. Carter walks across the street. Arriving firefighters were able to cap the underground tank to prevent an explosion. Fire crews remained on the site, flushing the gasoline from the storm drains. The damage was limited to the tanker and façade of the dealership.

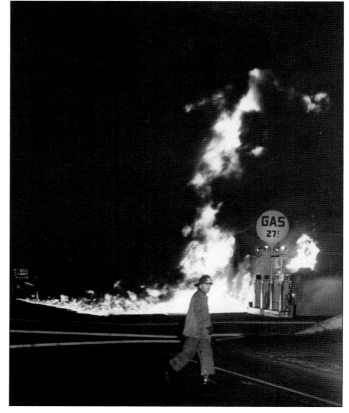

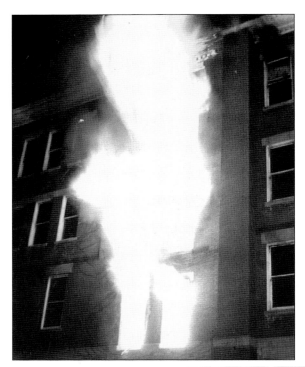

EXPLODING COMMODE. The Frazee Hall classroom building at the University of Kentucky received extensive damage in a January 1956 fire. Four engine companies were dispatched to the fire. The official report indicated that the fire "started when vandals blew up a commode in the basement . . . and ignited combustible materials outside of the restroom."

FRAZEE HALL. The aerial ladder was positioned through the smoke in January 1956 to battle the blaze at Frazee Hall on the University of Kentucky's campus. The building was erected in 1902, mostly of wooden construction. The university lost four other buildings during the previous 10 years. The loss was estimated at $200,000.

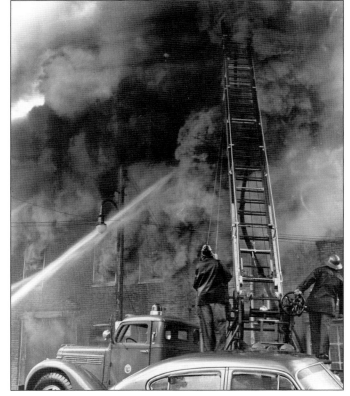

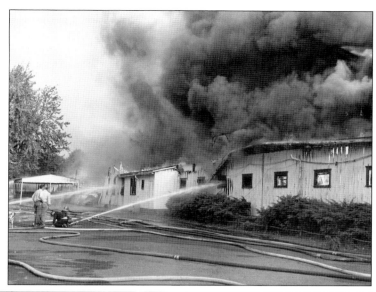

TATTERSALL. An early morning blaze destroyed the Tattersalls Sales Barn on South Broadway in October 1956. The fire had consumed most of the barn by the time the firemen arrived. The barn was built in 1913 after a fire destroyed its predecessor. Previous barns were also destroyed by fire in 1891 and 1904. The loss was placed at $70,000.

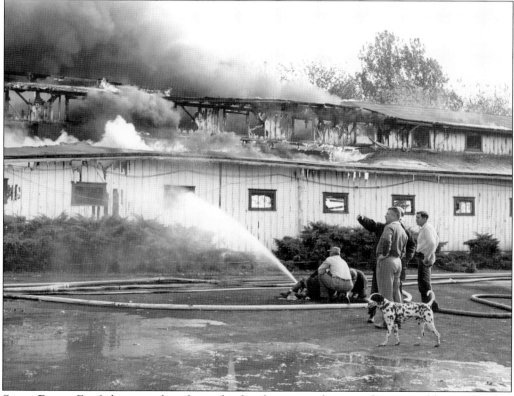

SALES BARN. Firefighters work to keep the fire from spreading to adjacent stables in October 1956, when the Tattersalls Sales Barn was destroyed. The company had sold saddlebred horses since after the Civil War. The department continued to spray water on the smoking hay for the next day. Later, two small boys admitted to starting the fire while playing firemen. No charges were brought against them.

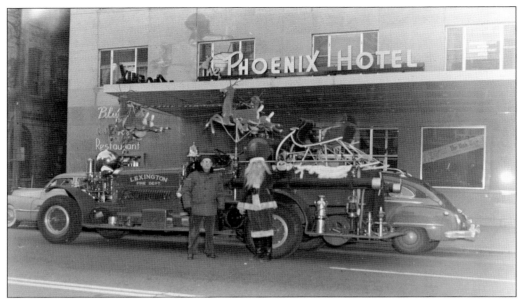

PHOENIX HOTEL. One of the Ahern-Fox pumpers decorated for the Christmas parade is seen in front of the historic Phoenix Hotel on Main Street in this c. 1954 photograph. Established as Postlethwaite's Tavern in 1797, the hotel was destroyed in 1820 and rose like a Phoenix from the ashes. The hotel was again destroyed by fire in 1879. (Courtesy of FOF.)

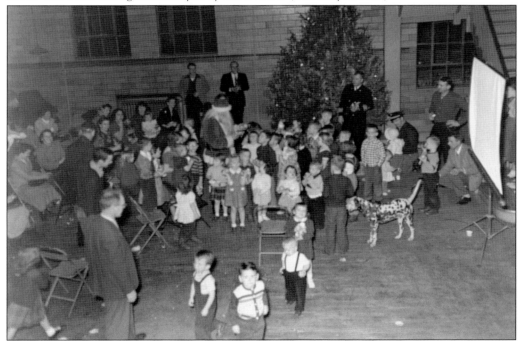

CHRISTMAS TOYS. Children surround Santa as he distributes toys to the boys and girls during the annual Toy Drive in about 1954. Note the Dalmatian, which has traditionally been a fire department mascot. They were originally employed to keep the horses company and protect them from street dogs. (Courtesy of FOF.)

Spectacular Blaze. The night sky was lit up with flames soaring hundreds of feet into the air in July 1959 when the Woolcott Flour Mill was destroyed by fire. The red glow in the sky was seen as far as Cynthiana, 33 miles away. The 1:08 p.m. alarm fire was quickly brought under control within 40 minutes, but the property was consumed.

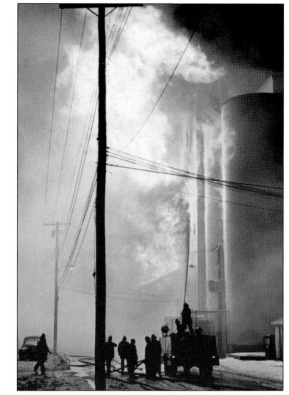

Inferno. The Woolcott Mill fire in July 1959 was so intense that buildings along the street were also soon engulfed in flames. The department dispatched eight engines and two ladder trucks to the blaze. The fire was determined to have been arson by a young man. The company estimated the loss at $250,000.

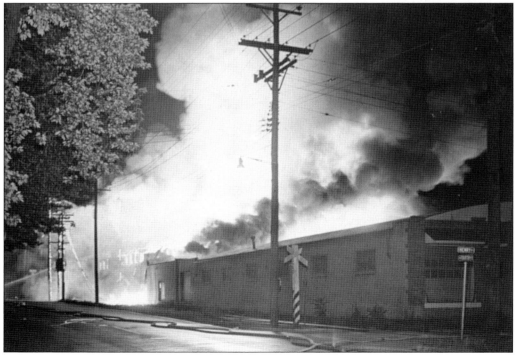

73

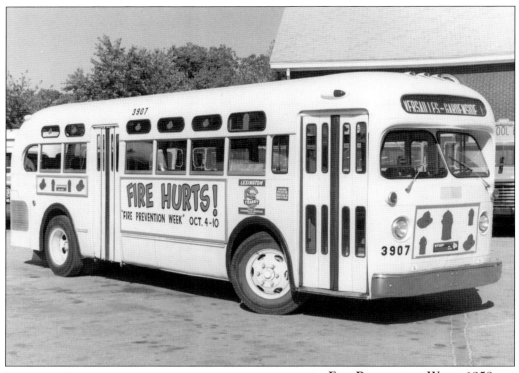

FIRE PREVENTION WEEK, 1959. One of the city buses advertised Fire Prevention Week, October 4–10, 1959. The annual program included open houses at all the fire stations, fire drills at all the city and county schools, and equipment demonstrations. No parade was held that year. (Courtesy of LFD.)

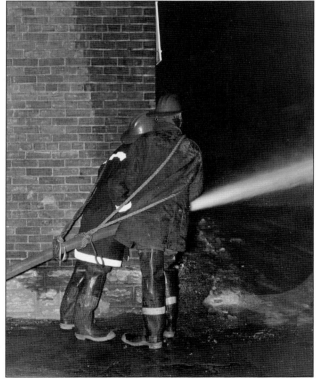

HIGH PRESSURE. Two firefighters use a rope lanyard to control a fire hose under high pressure (120-150 psi). One man directed the spray while the other secured the hose. When the fire alarm sounded, a fire gong at the pump room at the Richmond Road reservoir also sounded. Quickly, the waterworks raised the pressure from the standard 40 psi.

BUNK ROOM. The sleeping dormitory on the second floor of the Central Station is seen here around 1959. Most of the firefighters had military backgrounds, so sleeping in barracks was not new, but on a hot and humid summer night, sleep was often difficult. Air conditioning was finally installed during the 1970s.

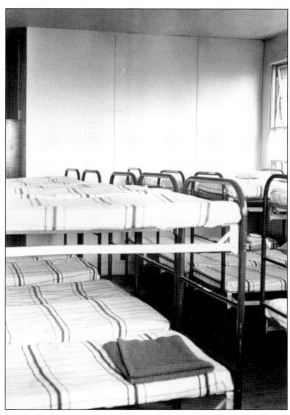

MOCK DISASTER. Seen here is a gymnasium set up for disaster training, with firefighters lying under debris waiting for rescue by their fellow firemen around 1960. The department was at the forefront of disaster planning during the Cold War era. During the Cuban Missile Crisis, preparation classes were given to the public at Station No. 6 until well past midnight every night.

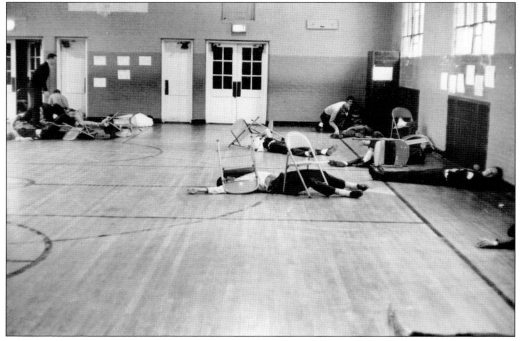

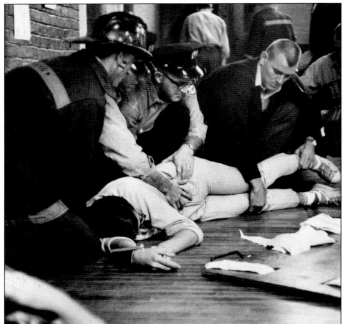

MOCK VICTIM. A firefighter assesses and stabilizes an "injured" firefighter during an annual civil defense disaster training session around 1960. The injured man will be placed on a backboard for transportation to the hospital outside. A training officer was appointed during the 1920s to oversee all training for the department.

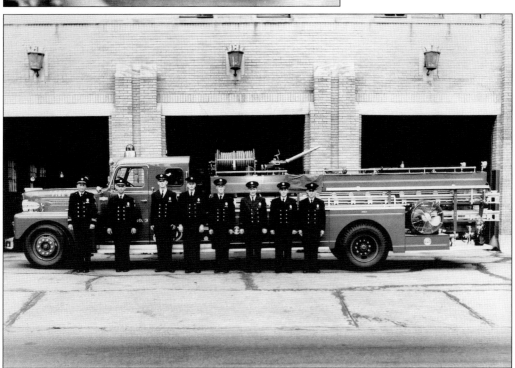

HOOK & LADDER. The new Ladder No. 2 was photographed in front of the Central Station on East Third Street in 1961. It was a quad engine, carrying a ladder, hose, pump, and water tank. The truck was dispatched with all fire runs from the station. Fireman John P. Malick is fourth from the left. Hook & Ladder Company No. 2 was established in 1922 at the Central Station.

REPAIRING THE LINES. Part of the department's responsibilities was inspecting and repairing the fire alarm wires. First installed in 1885, forty call boxes were positioned around the city, activated with a key and switch. Keys were deposited with citizens living nearby and with the police. This system remained in use until the 1960s.

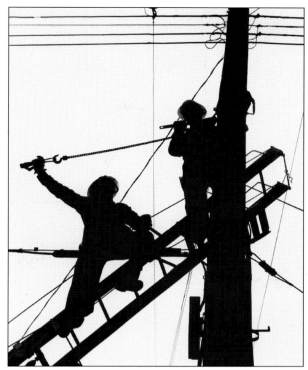

COUNTY FIRE CHIEF. J. Evans Berryman was appointed the chief of the county fire department in 1961. He oversaw the department's reorganization and expansion. At the time, the population of the county exceeded that of the city. He joined the Lexington Fire Department in 1921 before retiring in 1947 as training captain. Between 1947 and 1961, he organized the Kentucky Fire Training School. He retired in 1969.

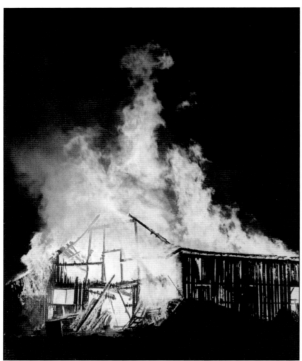

BARN FIRES. The wooden tobacco barns around Fayette County were susceptible to fire. Given their isolated locations, the Fayette County Fire Department usually arrived after they were fully engulfed. The firefighters' efforts were usually confined to preventing the fire from spreading to adjacent structures. As the population outside the city limits increased during the 1950s, the department developed into a suburban fire department.

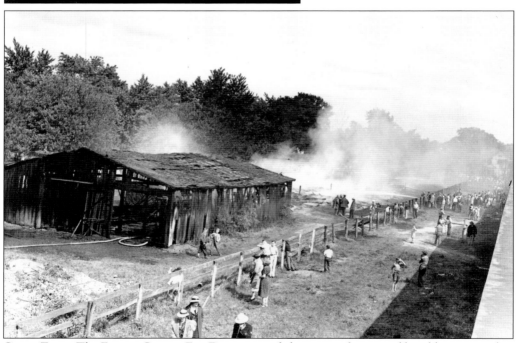

GRASS FIRES. The Fayette County Fire Department fights a grass fire caused by a blaze in another barn during the mid-1960s. These fires outside the hydrant district required the department to use a water tanker or water drawn from surrounding ponds and streams to battle the blaze. By the time the department arrived, most of these barns were lost.

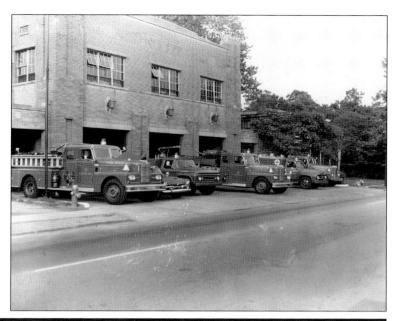

Fleet, 1962. The apparatus of the Central Station was photographed in 1962. From left to right are the 1962 Pirsch pumper, Plymouth chief's car, 1961 Ford Hose & Turret No. 1, 1961 Pirsch ladder truck, 1953 Ford salvage rescue truck, and 1959 Pirsch pumper. At the time, the city was served by six fire stations and the county by two.

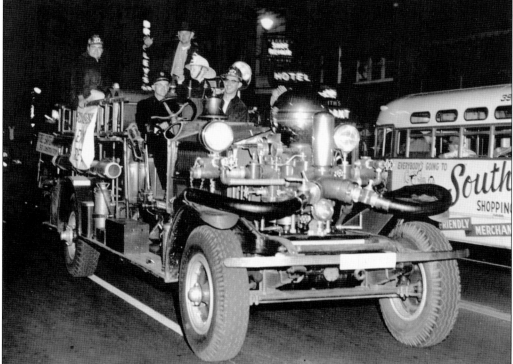

Box 212. A volunteer fire auxiliary was established in 1934 by John L. Carter, Burton Milward, Carl B. Wachs, and Chester H. Malick. The group assumed the name Box 212, which was the alarm code for the "lunatic asylum." They were trained to assist the department by handling hoses and ladders. The group also assisted in public relations, including the Fire Safe Christmas parade pictured here. The group disbanded in 1973.

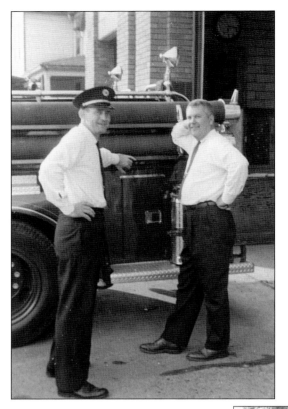

INFORMAL MEETING. Chief Earl R. McDaniel (right) and Assistant Chief Steve Logan talk in front of the Central Station around 1960. Chief Logan was in charge of the Fire Prevention Bureau, which was responsible for inspecting businesses open to the public. He was also in charge of public relations.

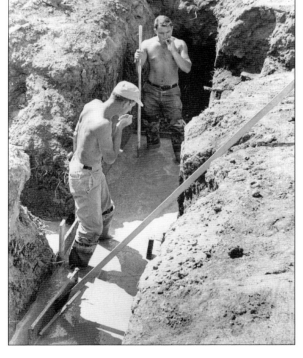

POURING CONCRETE. Fire Station No. 7 was built on Tates Creek Road in 1962 using the labor of the firemen. Labor unions objected, but the city estimated that it saved $20,000 to $30,000 on the cost. The department indicated at the time that it needed six additional fire stations.

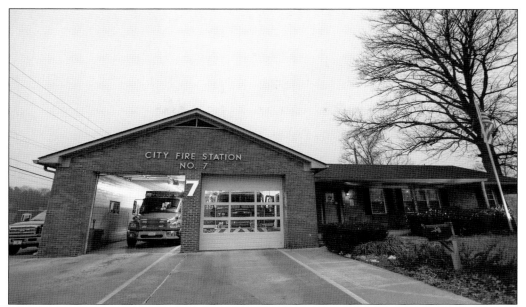

RANCH-STYLE FIREHOUSE. Located on Tates Creek Road and opened in 1963, this ranch-style firehouse was the first fire station built in almost 50 years. The same design was used for the next seven stations as additional areas were annexed. Legend has it that Chief McDaniel used his own house's plans with an oversized garage attached to save the architect's fee.

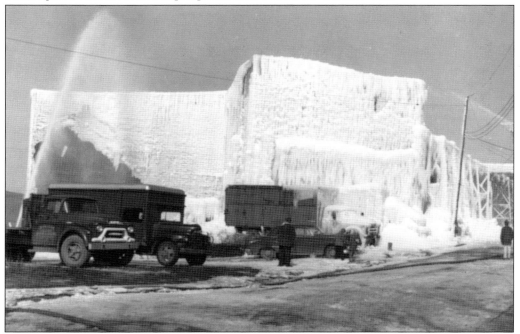

TEMPERATURE THREE DEGREES. Southern Ice Company on West High and Pine Streets was destroyed by fire in February 1963. Near-zero temperatures coated the building and firemen in ice. The fire smoldered well into the next day. The four-alarm fire, with two additional engines sent from the county to assist, caused damages estimated at $476,000.

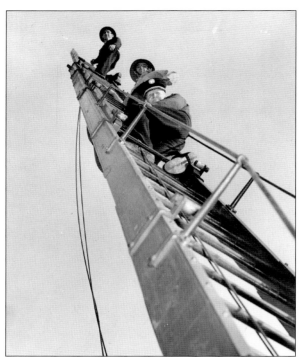

OLD HANDS. Pictured here is a ladder-climbing drill held for recruits at Central Fire Station on East Third Street during 1963. From top to bottom are G.D. Thompson, William C. Shea, and Capt. J.B. Sweeney. Captain Sweeney joined the department in 1921 and was the oldest serving fireman at the time.

EXPERIMENTAL STATION. At 1:00 in the morning, a blaze in a laboratory damaged the first floor of the Agricultural Experimental Station on the University of Kentucky campus during November 1963. The four-alarm fire resulted in the deployment of six fire engines. The fire was quickly brought under control, with damages limited to the laboratory and basement. The loss was estimated at $20,000.

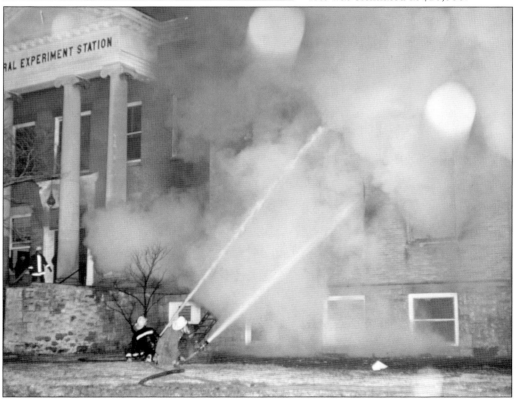

Freezing Weather. This courtyard off Mill Street was frozen solid after a fire in the early 1960s. The cold weather caused the water spray to freeze in the air, coating surfaces in ice. The ice also made handling a high-pressure hose difficult, which sometimes required the firefighters to lie down on the hose for control.

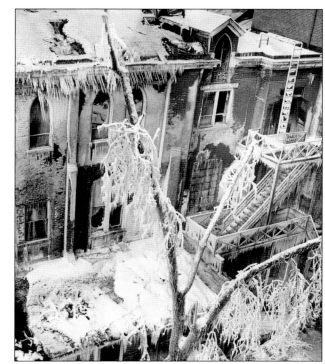

Cold Weather. Hypothermia, frostbite, and exhaustion are always a concern for firefighters battling fires in frigid weather. Fire suits are designed to protect against flames, not for warmth. Firefighters are swapped out frequently while fighting the fire. This is another view of the ice-covered courtyard off Mill Street in the early 1960s.

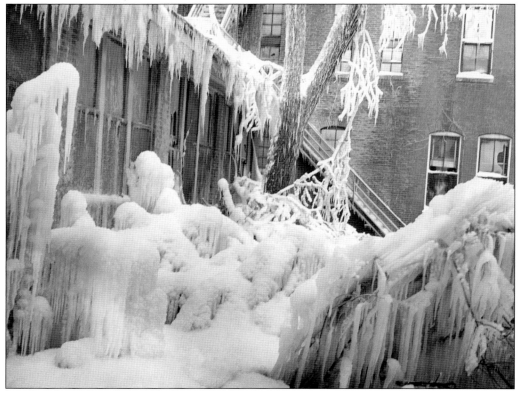

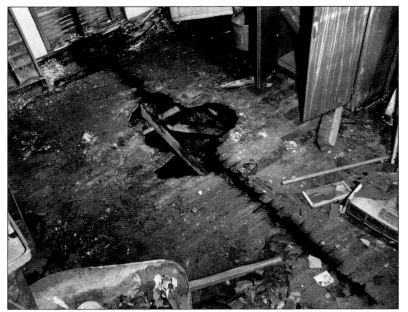

ARSON SUSPECTED. Arson is one of the leading causes of fires, and an arson investigator was appointed around the turn of the 20th century to investigate the causes of fires and to testify in criminal cases. This photograph shows where an accelerant was poured on the floor to start a fire.

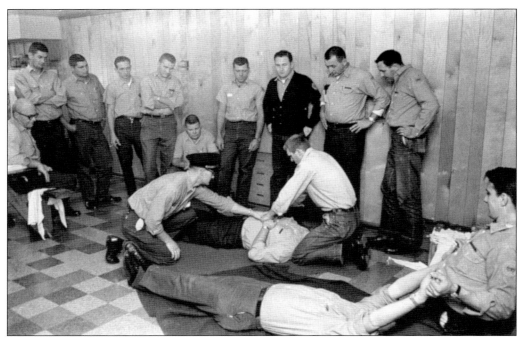

CPR TRAINING. Members of the department undergo first aid training during the 1960s as part of their duties. Chief Earl R. McDaniel instituted mandatory first-aid training for all firefighters, who were all tested annually during the 1950s. In 1969, he established the first Emergency Medical Service (EMS) unit.

BELOVED FIRE DOG. Flash joined the department as a five-month-old pup in August 1951 and was the first to answer fire calls from the Central Fire Station. He would watch the firefighters battling a blaze from the front seat of the engine. During his downtime, he would greet visitors, especially children, and beg for food. His son, Smokie, oversaw Station No. 6. Flash died in December 1963.

EAST MAIN FIRE. In May 1964, Porter's Auto Supply was destroyed during the night by a fire. The roof collapsed on five automobiles being repaired. The department dispatched five pumpers and three ladder trucks to the scene. The store on East Main Street suffered over $200,000 in damages.

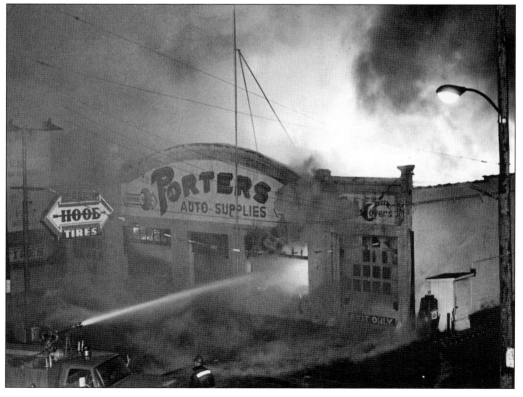

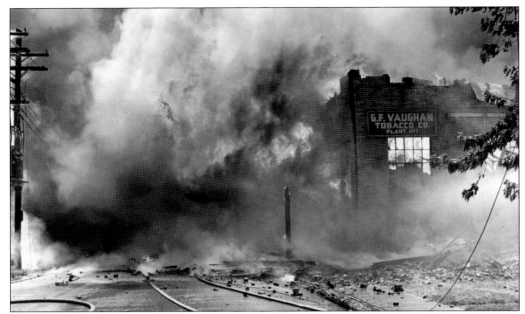

TOBACCO REDRYING PLANT. The redryer plant of the G.H. Vaughn Tobacco Company at 422 Angliana Avenue was destroyed in a four-alarm fire in August 1964. Eleven firefighters were injured when the front brick wall collapsed. The tobacco processing plant was a total loss, estimated at $487,500. The department saved the adjacent warehouses containing over $2 million worth of tobacco.

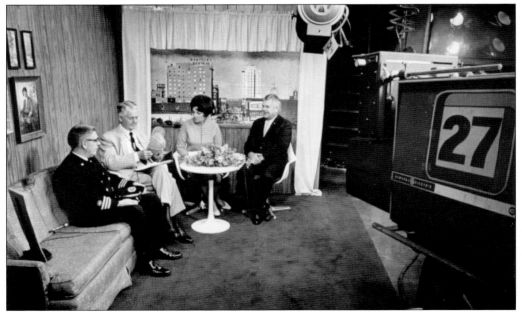

CHANNEL 27. Chief Earl McDaniel is pictured during an interview by Ted Grizzard and June Rollins on Channel 27's *Town Talk* program during Fire Prevention Week in the early 1960s. The man at far left is unidentified. Fire Prevention Week has been held annually in October since 1911, the 40th anniversary of the Great Chicago Fire.

SANTA ENGINE. Fireman Billy Toomes rests before the annual Christmas Parade on a cold December day in the early 1960s. The parade was instituted in the 1950s and was a mainstay of the season for 30 years. The 1926 Ahrens-Fox fire engine was the centerpiece of the parade for years.

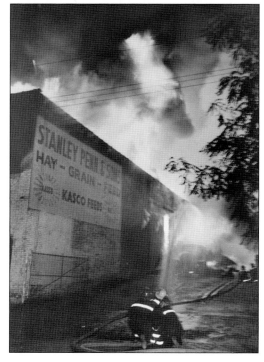

FEED WAREHOUSE. Stanley Penn & Sons on West Pine Street was destroyed by fire just after midnight one day in September 1964. The firm specialized in hay and oat feed for racehorses. Flames roared through the building in less than 30 minutes, fed by the hay and grains. The fire was brought under control in about an hour, but not before damaging a nearby house.

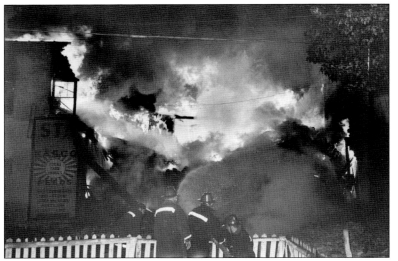

ANOTHER VIEW. The flames lit up west Pine Street in the September 1964 fire at Stanley Penn & Sons. The department remained on site until the next morning, spraying hot spots and nearby buildings with water. Arson was suspected, with a report of several men loitering in the vicinity.

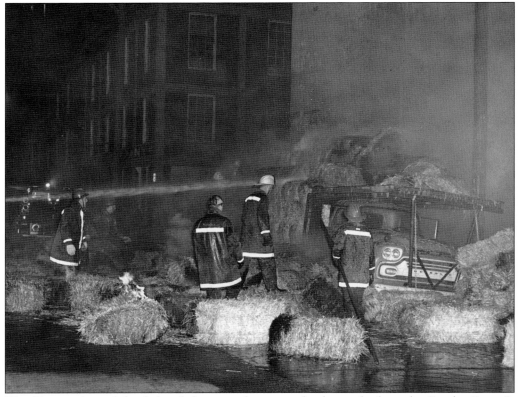

HAY TRUCK. A truck loaded with hay was also set on fire by sparks from the Stanley Penn & Sons fire in September 1964. Smoldering hay bales were dragged off the truck and spread across Pine Street. The truck was not damaged. The losses from the fire were estimated at $70,000.

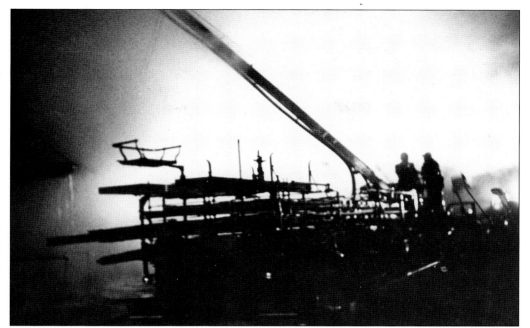

LADDER TRUCK. The 75-foot American LaFrance aerial wagon was purchased for $16,500 by the city in 1929. The ladder was assigned to Hook & Ladder Company No. 1 at the Central Station. It was retired in 1966 after 37 years of service. The department has retained the unit, and it is currently stored at Station No. 10 as a vintage engine.

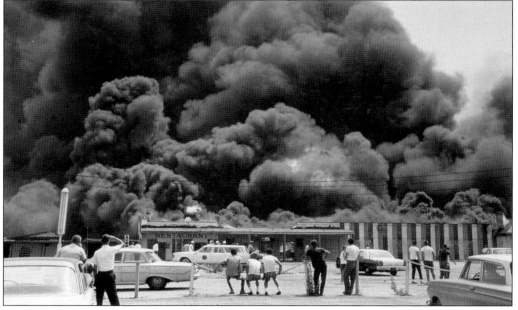

JOYLAND FIRE. On June 21, 1965, the clubhouse at the Joyland Amusement Park on Paris Pike was destroyed by fire, which raged out of control for over two hours. Enormous black clouds were visible as far away as Paris and Winchester. Both the city and county departments responded. Three buildings were destroyed, with a $200,000 loss.

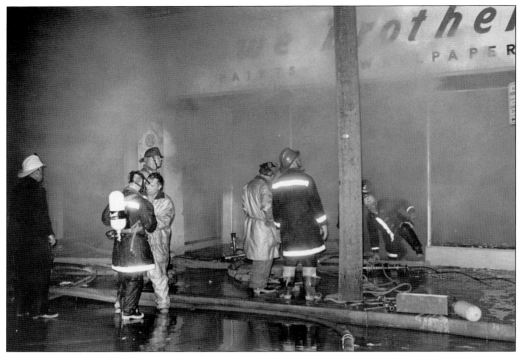

LOWE BROTHERS PAINTS. In July 1967, Lowe Brothers Paints and Maico Hearing Aids on North Upper Street were both destroyed by a midnight fire. The four-alarm fire resulted in $18,700 in losses. The toxic smoke overcame 17 firefighters during the two-hour battle against the flames. Three square blocks were cordoned off because of the smoke.

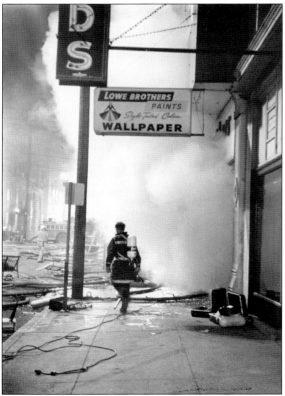

SMOKE BILLOWING. An exhausted fireman walks toward the smoke billowing from the Lowe Brothers Paints store on North Upper Street. Hoses litter the street. Seven engines responded to the fire, with nine hose lines laid. The department exhausted its supply of air masks, and firefighters fought the blaze in relays.

FIRE CONTAINED. An early morning fire was quickly contained at Ades Dry Goods at 249 East Main Street in January 1968 in sub-zero temperatures. The 1956 Pirsch aerial ladder truck allowed firefighters to reach the fourth floor. East Main Street was closed for most of the morning as city salt crews worked on the accumulated ice.

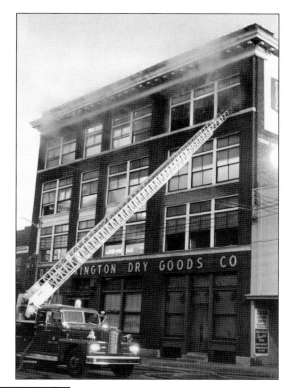

WATER SPOUT. The 1956 Pirsch ladder truck was equipped with a 50-foot pipe attachment, called a water spout, for fighting fires on higher floors. The extension was remotely controlled so that a firefighter was not required to operate from the top of the ladder. The ladder was without a pump, so water had to be supplied from hydrants or another pumper.

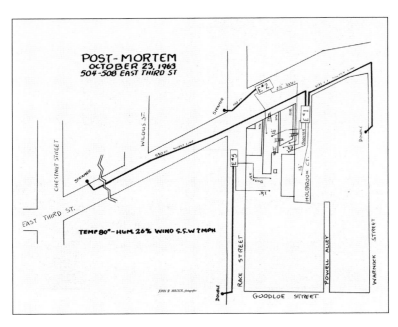

POST-MORTEM. After-action recorded the placement of fire engines fighting a residential fire on East Third Street in October 1963. The report indicated that the temperature was 80 degrees, the humidity was at 26 percent, and the south-southwest wind was at seven miles per hour. The department used these reports for training purposes. This report was prepared by John P. Malick.

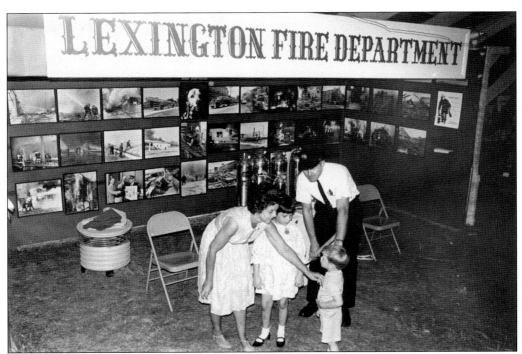

FAIR GREETINGS. The Fire Prevention Bureau's display at the annual Blue Grass Fair during the early 1960s is seen here. The fair was held at the Red Mile racetrack on Versailles Road. The bureau was assisted by the Women's Auxiliary of the Lexington Fire Department. The auxiliary consisted of the wives of the firefighters.

Santa Engine. Following World War II, the annual Christmas parade following Thanksgiving was the Christmas season's kickoff. The department would promote Fire Safe Christmas during the season as part of its fire prevention outreach. The old 1926 Ahrens-Fox pumper, then in reserve, participated in these parades around 1963.

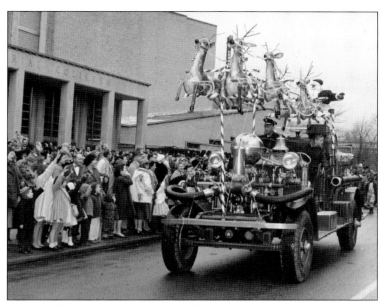

Kid-Friendly. A kid-friendly display for Fire Prevention Week was set up on Main Street at the Harrison Viaduct in October 1964. The viaduct was built adjacent to Union Depot to convey Walnut Street (now Martin Luther King Boulevard) over Water Street's railroad tracks. Ladder No. 1$^{1/2}$ and a chief's car are ready for use by the small firefighters.

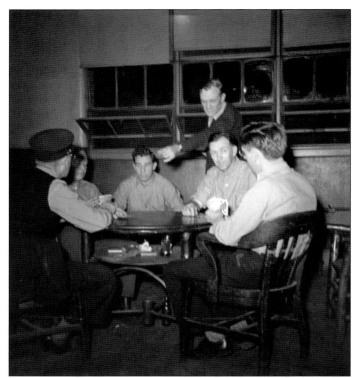

Downtime. Firefighters at Fire Station No. 6 on South Broadway play cards to pass the time. Regulations prohibited gambling. During a 24-hour shift, a firefighter had downtime between their assigned duties. In the late 1960s, the firemen at each station contributed to purchasing a television set to watch the three local channels. Televisions were not budgeted for new stations until decades later.

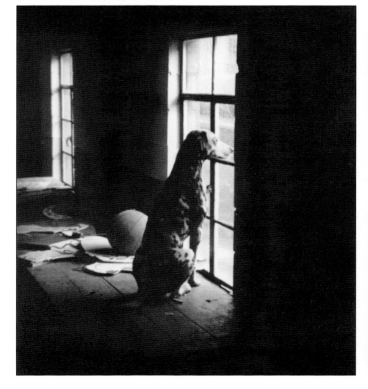

Smokie. Smokie keeps a watchful eye on the training of recruits at the training tower at Station No. 6 during the early 1960s. He was the son of Flash, the fire dog of the Central Fire Station. Smokie met every visitor to the station, especially children, hoping for a treat.

Long Way Down. This view from the top of the five-story training tower on South Broadway shows the 1956 Pirsch aerial ladder around the early 1960s. Firefighters were trained to rapidly climb the ladder to the top of the training tower. Using smaller ladders, they were also trained in hauling hoses to windows in lower stories.

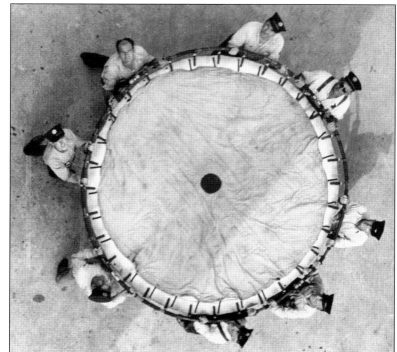

Jump. All recruits to the department received extensive training, including jumping from the training tower into the life net. Originally patented in 1887, the Browder Life Safety Net was intended to allow people to jump from a higher floor of a building to escape a fire. This photograph is from the early 1960s.

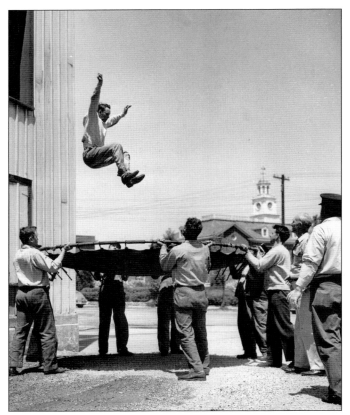

Right on Target. A fireman jumps from the training tower into the life net during the early 1960s. These nets were seldom used, as the risk of injury to both the jumper and those holding the net was high. Until the 1960s, only one building in Lexington exceeded the reach of the aerial ladder.

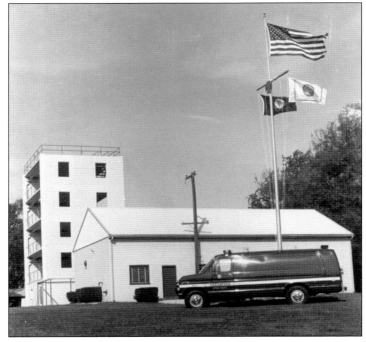

New Training Center. In 1969, the department opened a new concrete block training center and classroom on Old Frankfort Pike along the South Elkhorn Creek. The site was filled in with demolition rubble from Water Street. The building and grounds cost $30,000, and the adjacent 48-foot training tower cost $22,200. Recruits were required to undergo nine weeks of training. (Courtesy of LFD.)

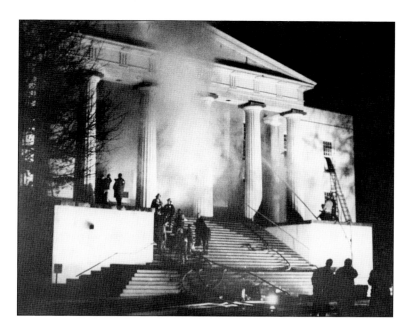

OLD MORRISON HALL. In January 1969, the historic Morrison Chapel at Transylvania University on Third Street was gutted by a four-alarm fire. The department responded with 12 fire engines but was unable to prevent over $600,000 in damage. The building was completed in 1833 after a bequest of Col. James Morrison, managed by Henry Clay, his executor. (Courtesy of LFD.)

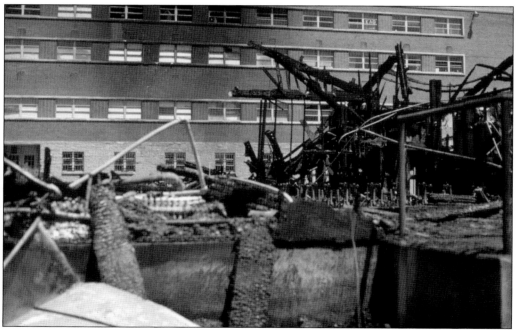

ROTC BUILDING. The Air Force ROTC building on the University of Kentucky's campus on Euclid and Harrison Avenues was destroyed during an anti-war protest in May 1970. A co-ed was charged with arson for setting the fire with a Molotov cocktail. Blazier Hall in the background was scorched during the fire. (Courtesy of UK.)

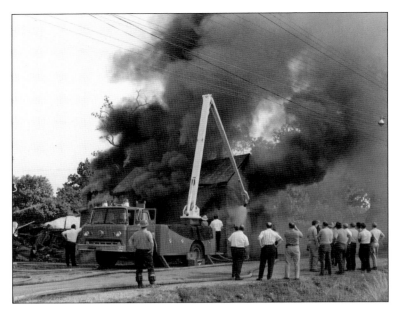

PASSES INSPECTION. The new Water Tower No. 1 was demonstrated to a group of firefighters in 1972. The department set fire to one of the old frame farmhouses in the county. The remote control unit handled the fire using only one man. The tower had a capacity of 1,200 gallons per minute. (Courtesy of LFD.)

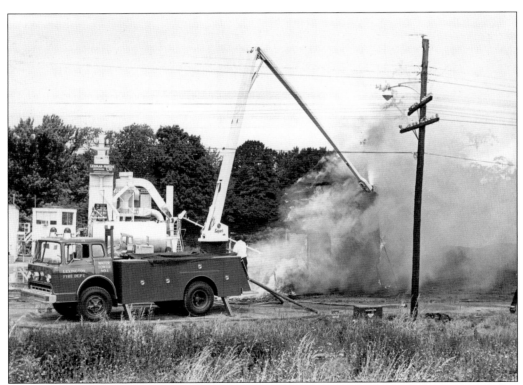

ASPHALT FIRE. Water Tower No. 1 fights a fire at the Lehman Meade Asphalt plant on Forbes Road at Old Frankfort during the early 1970s. The tower required only one man to operate. It was stationed at the old Elm Tree firehouse on Sixth Street. (Courtesy of LFD.)

Five
MERGED GOVERNMENT 1974–2021

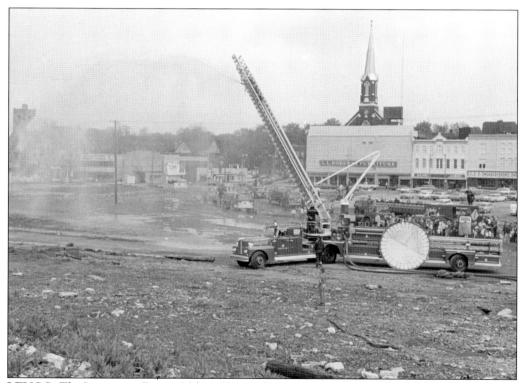

LFUCG. The Lexington-Fayette Urban County Government was created in 1974 with the merger of the city and county governments. The Fayette County Fire Department was consolidated into the Lexington Fire Department at that time. This photograph shows an aerial ladder spraying water on Vine Street at West Main Street. The site was being prepared for the construction of the Lexington Civic Center and Rupp Arena. (Courtesy of LFD.)

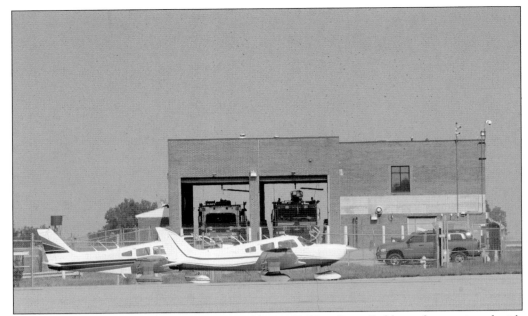

BLUE GRASS FIELD. Built at the start of World War II, Blue Grass Field was first equipped with a couple of emergency pickup trucks with fire extinguishers, and later with a 20-year-old surplus county pumper. In 1979, the fire station seen here was built along the main runway. The station was equipped with three crash trucks and one rescue truck. (Courtesy of BGA.)

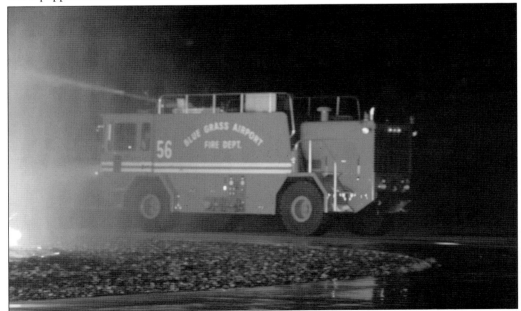

CRASH TRUCK. The airport was equipped with three specially designed crash trucks for fighting aircraft fires. This 1986 Oshkosh T-1500 was equipped with a 1,000-gallon-per-minute pump, a 1,500-gallon fiberglass tank, and a 200-gallon foam tank. A turret in front directs a water form mixture onto a fire. With a top speed of over 70 miles per hour, these all-wheel-drive trucks could reach an accident quickly. (Courtesy of LFD.)

ADMINISTRATION BUILDING. The old College Building at the University of Kentucky was gutted by fire in May 2001 while under renovation. It was erected in 1882. Five fire companies were dispatched, including seven engines and two ladder trucks. The first fire crew arrived within two minutes from Station No. 6 across the street, and the fire was brought under control after one and a half hours. (Courtesy of LHL.)

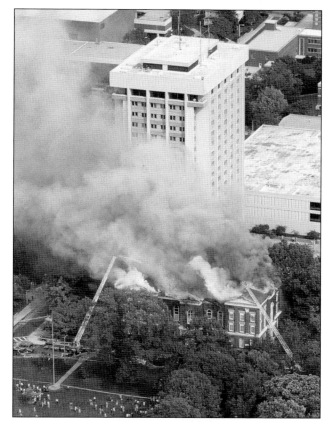

THE CAVE. The most unique firehouse in Lexington is Station No. 16 on Man-O-War Boulevard, covering the southeast portion of the city. The station is three concrete domes covered with an earth embankment. The energy-efficient design is nicknamed "the Cave." The station initially housed Engine No. 16 and Ladder No. 6. (Courtesy of LFUCG.)

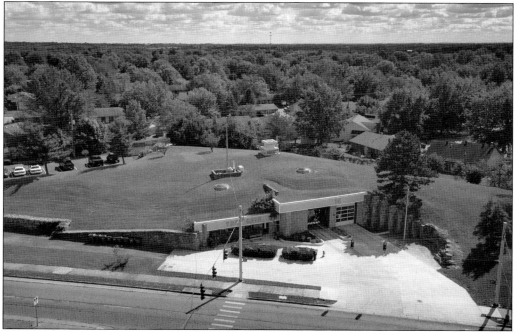

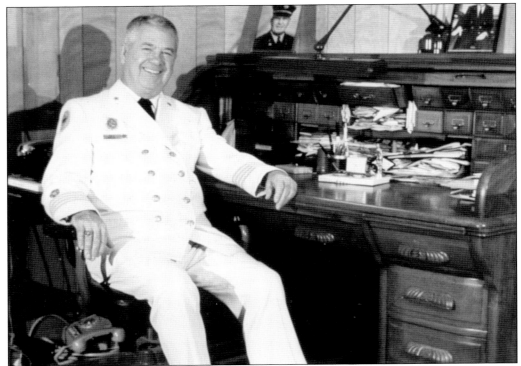

CHIEF MCDANIEL. Earl R. McDaniel retired on December 27, 1986, on the same date that, 36 years earlier, he had been appointed chief. He oversaw the modernization of the Lexington Fire Department from third-class with six stations to a first-class department with 18 stations equipped with modern fire apparatus. During his tenure from 1949 to 1986, Lexington was twice ranked first in the nation for cities of its size.

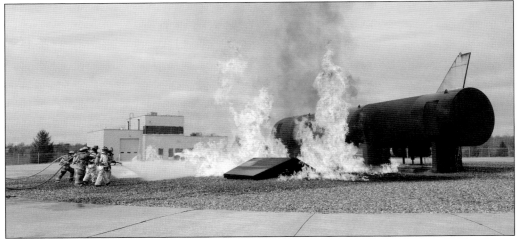

ARFF TRAINING CENTER. A regional Aircraft Rescue and Firefighting training center was established on 200 acres adjoining the Blue Grass Airport in 1998. The FAA requires that all firefighting personnel meet a minimum standard and have annual recertification. The center provides both a weeklong basic class and refresher training classes. It is one of 40 across the country. (Courtesy of BGA.)

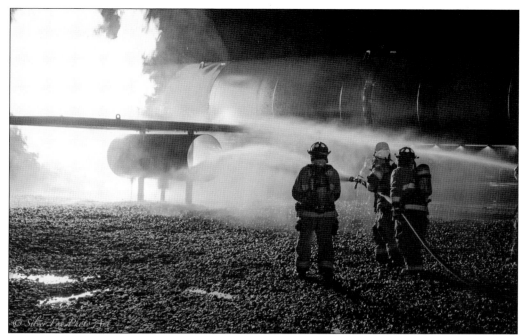

SAFT. Trainee firefighters battle a blaze on the Specialized Aircraft Fire Trainer designed to represent a Boeing 737 at the ARFF training center. A computer-controlled simulator duplicates large-scale flammable liquid, engine, wheel, and brake fires, and interior fires. The flames are provided by propane. Crash truck training is also provided. (Courtesy of BGA.)

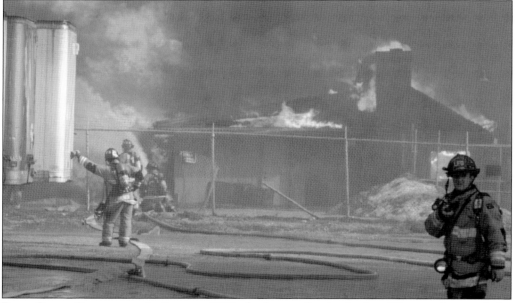

Blue Grass Stockyard. In January 2016, the largest fire in the last 30 years destroyed the seven-acre Blue Grass Stockyard. The blaze was discovered at 2:20 p.m., and within minutes, as the first units had arrived, high winds had spread the fire to neighboring businesses. In total, five businesses were destroyed, along with over 100 automobiles. The stockyards were empty at the time.

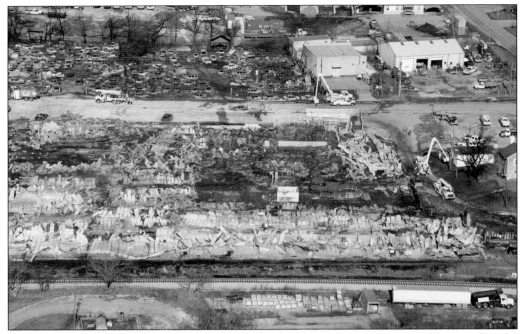

AFTERMATH. The total devastation of the Blue Grass Stockyard was caused by accident by workmen repairing the roof in January 2016. Massive thick plumes of black smoke from the fire were reported visible as far away as Louisville. The department deployed a quarter of the city's fire resources, with 16 fire engines and over 120 firefighters.

CLASS 1 RANKING. In March 2017, Mayor Jim Gray and Fire Chief Kristin Chilton announced a class 1 ranking for the city of Lexington by the Insurance Services Organization. Previously the city had a class 2 ranking. Only 241 fire departments in the nation were given the highest ranking, including seven other departments in Kentucky. (Courtesy of LFUCG.)

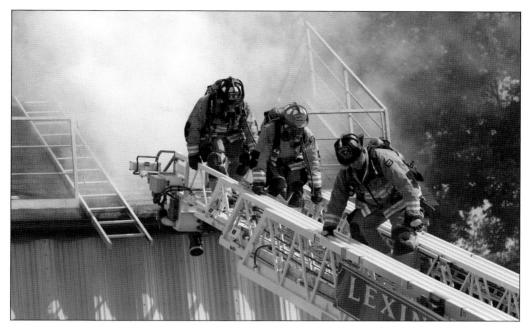

NEW LIEUTENANTS. The department instituted a five-week training program for newly promoted lieutenants in 2012. A lieutenant is in charge of a fire truck and two firefighters. Topics include fire ground tactics to elevator emergencies, as well as leadership, report writing, and diversity training. Seen here is a drill at the training center in 2017. (Courtesy of LFUCG.)

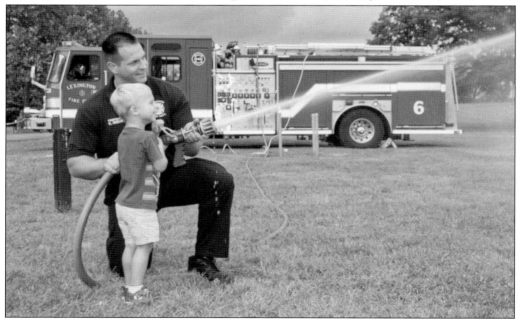

FIRE PREVENTION FESTIVAL. In October 2017, the department held its annual Fire Prevention & Wellness Festival at Masterson Station Park. Several thousand attended. The festival included fire truck rides and firefighting demonstrations, with pony rides, a bouncy house, children's games, and food. In addition, health screenings for the public were conducted. (Courtesy of LFUCG.)

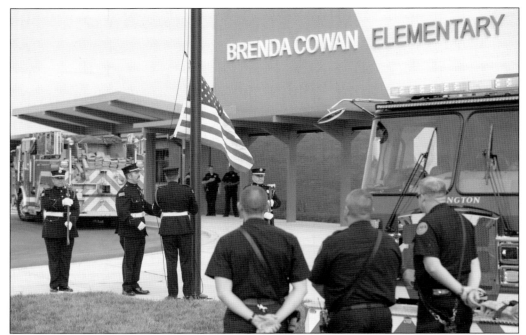

BRENDA COWAN ELEMENTARY. Lexington Fire Department's honor guard raised the flag before the ribbon-cutting for Brenda Cowan Elementary in August 2019. The school was named for Lt. Brenda Cowan, the first African American female firefighter in Lexington. She died in the line of duty while responding to a domestic violence call in February 2004. (Courtesy of LFUCG.)

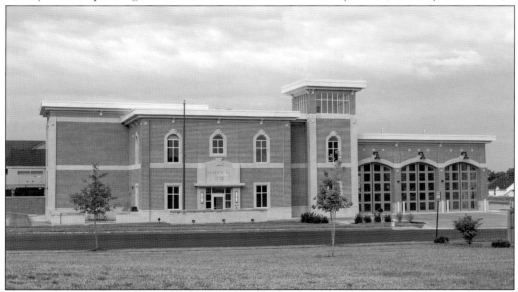

STATION NO. 24. This new fire station was dedicated in August 2019 on Magnolia Springs Drive to cover the northwest side, including Masterson Station and the surrounding subdivisions. The station was designed with the latest technology for energy efficiency. The furniture and fixtures were made by Kentucky Correctional Industries. The station houses Engine No. 24 and Tanker No. 1. (Courtesy of LFUCG.)

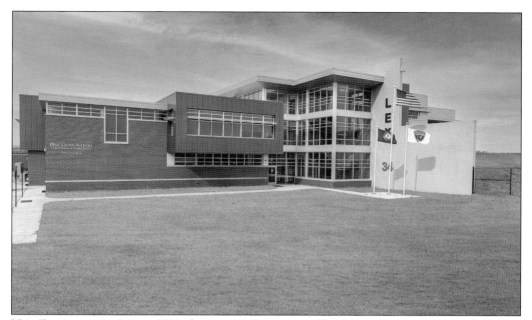

NEW FIREHOUSE. In August 2020, the new ARFF station at Blue Grass Airport was opened at a cost of $15 million. The three-story building contains four equipment bays and offices on the ground, residential spaces on the second, and an observation area on the third floor. (Courtesy of BGA.)

TOY DRIVE. Mayor Linda Gordon (at podium) and Fire Chief Kristin Chilton kick off the annual Lexington Fraternal Order of Firefighters Toy Program in October 2020. Over 2,200 children up to the age of 12 received various toys, such as dolls, bikes, balls, action figures, and games for boys and girls. (Courtesy of LFUCG.)

Chief Wells. Retired battalion chief Jim Wells pins the fire chief's badge on his son Jason G. Wells on January 4, 2021. Both wear masks due to the COVID-19 epidemic. Chief Jason Wells is a 25-year veteran of the department, including serving at the haunted Vogt Firehouse early in his career. He is the 19th chief of the Lexington Fire Department. (Courtesy of LFUCG.)

Six
FIRE APPARATUS 1871–2021

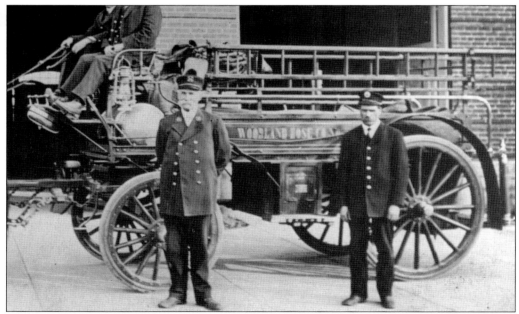

SEAGRAVE COMBINATION WAGON. This combination hose and chemical wagon was purchased in 1905 from Seagrave Manufacturing Company of Columbia, Ohio, for $1,750. The wagon had a 40-gallon chemical engine with 1,000 feet of hose and hard rubber tires. The tank under the driver's seat was the chemical engine (a tank pressurized with soda water and acid).

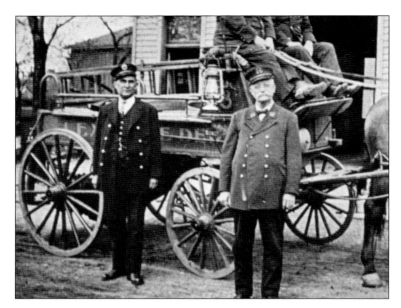

Hose Wagon. In April 1899, the city purchased a hose wagon for $210 built by Joseph F. Chevalier. The wagon was equipped with 800 feet of hose. Chevalier was a wagon maker in Lexington. The wagon was delivered in June and assigned to Hose Company No. 3.

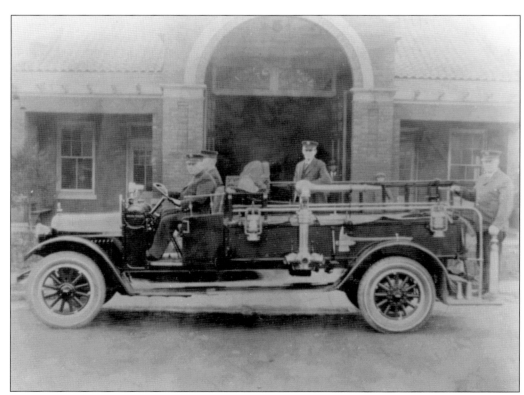

REO Turret Truck. A turret truck was built in 1926 from an REO truck chassis and the bed from an old horse-drawn Seagrave hose wagon. The truck was not a front-line unit but a supplement at larger fires. It was supplied with water directly from a hydrant. (Courtesy of LFD.)

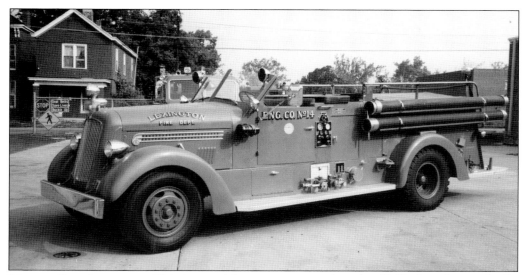

MODERN FIRE APPARATUS. This is one of three pumpers purchased in 1948 when the city finally began modernizing the department with new equipment. The unit was manufactured by the Seagrave Company of Columbus. Except for the 1939 International quad, the entire fire fleet had been in service for more than 20 years by the end of the war. (Courtesy of LFD.)

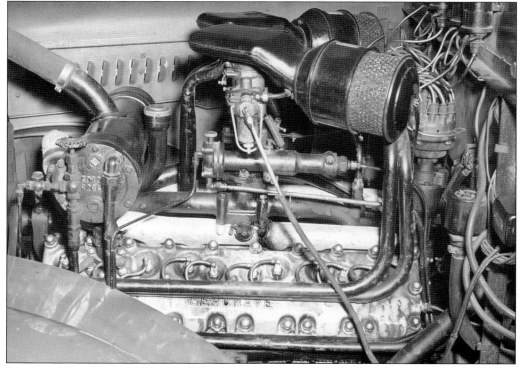

SEAGRAVE POWERPLANT. The 1948 Seagrave pumpers were equipped with 531-cubic-inch V-12 engines. The motor had dual ignition with four coils, two distributors, and 24 plugs. The open cab engine had a capacity of 1,000 gallons per minute and a 200-gallon booster tank. The engine proved highly reliable when placed into service. (Courtesy of LFD.)

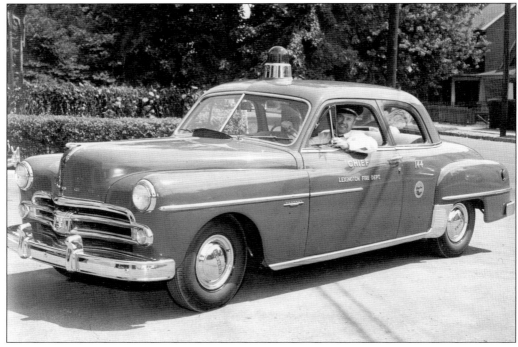

CHIEF'S CAR. The fire chief was assigned a buggy and driver during the 1880s. The horse-drawn buggy was retired for a Rambler motor car in August 1913, built by the Thomas B. Jeffrey Company of Kenosha, Wisconsin, at a cost of $2,000. Pictured here is another chief's car, a 1950 Dodge Special Deluxe. (Courtesy of LFD.)

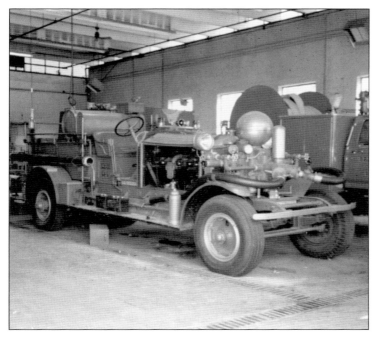

ORIGINAL ENGINE NO. 6. This 1926 Ahrens-Fox pumper was purchased in January 1927 for $13,250. In June 1927, the new engine was driven from the factory in Cincinnati to Lexington. This engine was powered by a T-head 998-cubic-inch, six-cylinder gasoline engine with dual ignition and a three-speed manual transmission. It is equipped with a 1,000-gallon-per-minute pump and a 100-gallon booster tank. (Courtesy of LFD.)

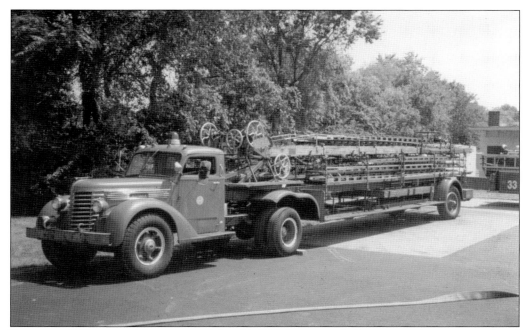

Diamond T Tractor. The tractor of the old 1929 American LaFrance aerial unit was replaced in 1951 with a 1947 Diamond T tractor cab after the engine blew up. The old 1929 seventy-five-foot ladder trailer remained in service until 1966 and remains in storage today. (Courtesy of LFD.)

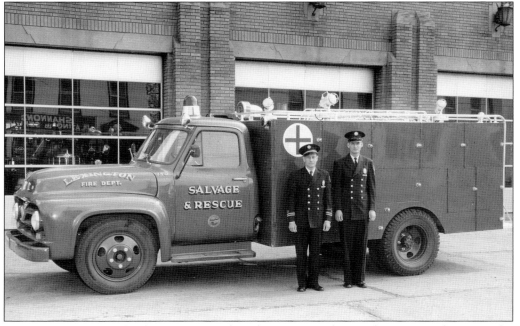

Salvage & Rescue. The department purchased a two-ton utility truck in 1953 and converted it into the Salvage & Rescue truck. The unit carried first-aid equipment, including stretchers, oxygen bottles, inhalators, and an iron lung. A stretcher could be loaded into the center compartment. (Courtesy of LFD.)

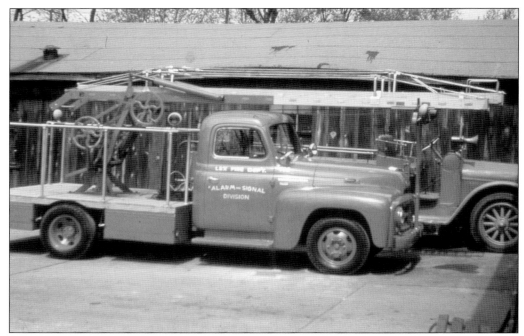

LINE MAINTENANCE. The Alarm & Signal truck was used by firemen in repairing the alarm lines around downtown. When the fire alarm boxes were installed in 1885, they were connected by a separate wire strung on the telephone poles. The department also changed streetlights for the city. This image was captured around 1954. (Courtesy of LFD.)

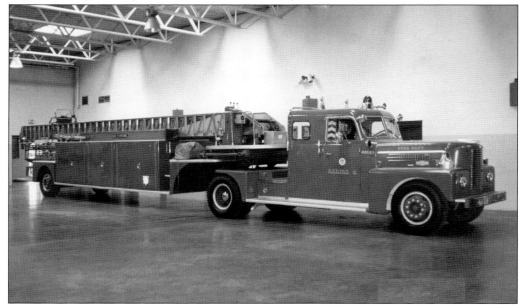

PIRSCH LADDER TRUCK, 1956. In April 1956, the city purchased a new ladder truck for $36,247 from Peter Pirsch & Sons of Memphis. The truck was equipped with a 100-foot ladder, a 50-foot water pipe, a generator, and floodlights. It was named *Earl R. McDaniel* after the former fire chief's retirement. The ladder truck was retained until the 1980s. (Courtesy of LFD.)

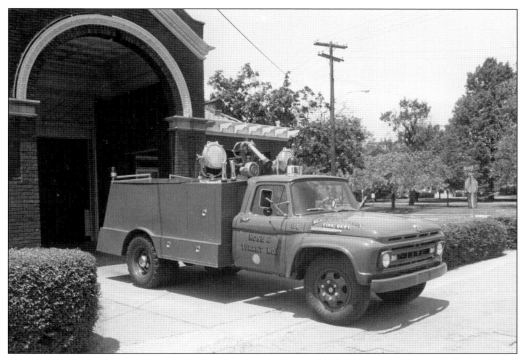

HOSE & TURRET TRUCK. Assigned to Station No. 6, Hose & Turret No. 1 was built on a 1961 Ford truck chassis. The unit was an inexpensive addition to the apparatus roster equipped with a turret and a supply of hose. It could be deployed to fires with access to fire hydrants to provide water. Station No. 6 served the University of Kentucky campus. (Courtesy of LFD.)

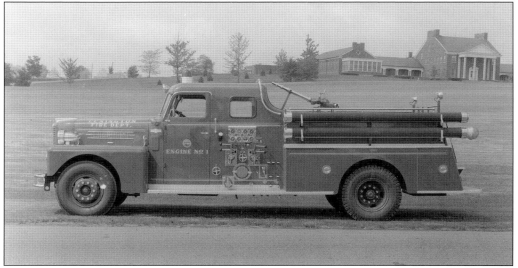

ENGINE NO. 1. Pictured here is the 1962 Pirsch crew-cab pumper assigned to Engine Company No. 1 at the Central Fire Station. The company's origins trace back to Steam Engine Company No. 1, established in 1864 when a Silsby steam engine was purchased by the city. The 1,000-gallon-per-minute pumper is seen in front of the Shriners Children's Hospital on Richmond Road. (Courtesy of LFD.)

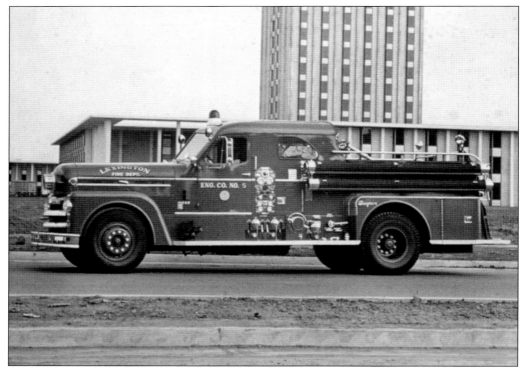

ENGINE NO. 5. This 1963 Seagrave crew cab triple combination pumper was photographed in front of the Kirwan-Blanding housing complex around 1967. The engine was assigned to Station No. 5 on Woodland Avenue to cover the Chevy Chase section of Lexington. The station was the original home for Hose Reel Company No. 5 in 1904. (Courtesy of LFD.)

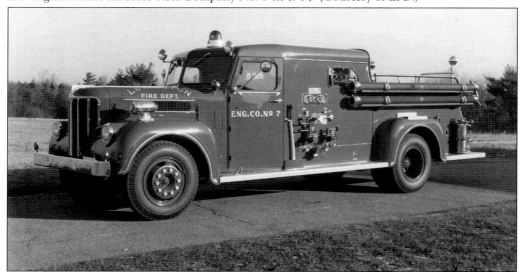

MAXIM, 1965. In 1965, three Maxim pumpers were purchased at $23,500 each. The engine carried 200 gallons in an internal tank, with a pumping capacity of 1,000 gallons per minute. Engine No. 7 was assigned to the new station on Tates Creek Road, serving the expanding southeast section of the city. (Courtesy of LFD.)

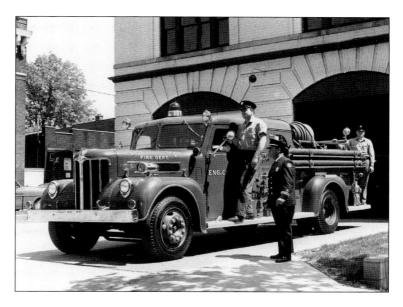

WOODLAND STATION. Engine No. 5's crew pose with their new engine, an enclosed cab 1965 Maxim, in front of Woodland Station No. 5 around 1966. The station served the expanding suburbs around the Chevy Chase Shopping Center on the southeast side. The station also housed Ladder No. 2. (Courtesy of LFD.)

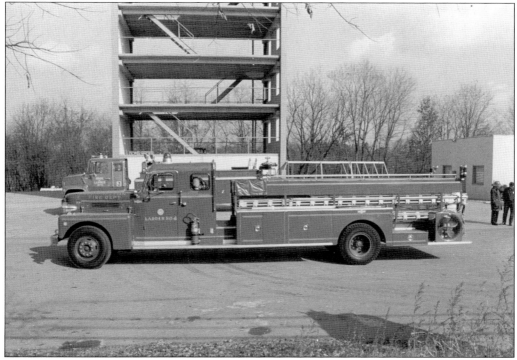

HOOK & LADDER COMPANY NO. 4. Formed in 1968, Hook & Ladder Company No. 4 was assigned to Station No. 11 on Harrodsburg Road. The company was equipped with a new Pirsch Ladder to service the western suburbs of the city. It was reorganized as Ladder Company No. 4 in 1980. (Courtesy of LFD.)

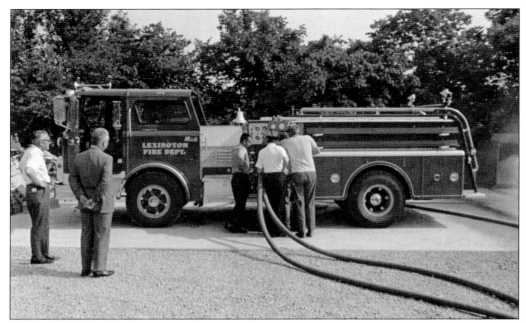

CAB FORWARD. The first cab-over fire engine was purchased in 1970 from Mack Trucks for $34,750. The position of the cab at the front of the truck provided greater visibility when driving. The 1,000-gallon-per-minute pumper was also the first diesel engine. The internal tank carried 300 gallons. The unit was removed from service in 1988. (Courtesy of LFD.)

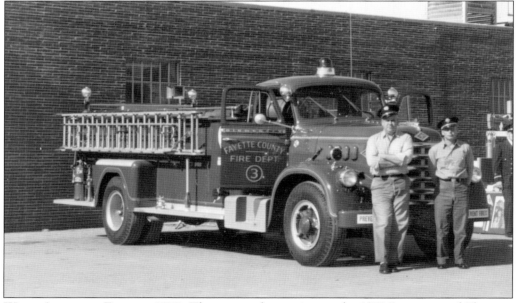

WARD AMERICAN ENGINE, 1970. The county fire engine used a 1970 International Fleetstar truck chassis with a Ward LaFrance pumper bed. The pump had an operating capacity of 1,000 gallons per minute with a 1,000-gallon tank on the back. The fire apparatus was manufactured by the Ward LaFrance Truck Company, founded in 1916 by the son of the founder of the American LaFrance Fire Engine Company.

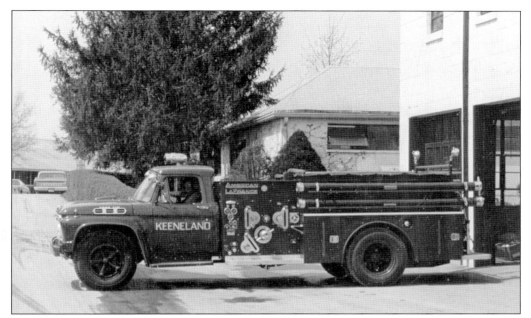

KEENELAND RACE TRACK. The Keeneland Association operated a fire engine to protect the grandstands and horse barns between the 1960s and 1980s. The racetrack on Versailles Road, across from the airport, maintains its own water supply, with hydrants throughout its 55 barns on 1,000 acres. The engine was a 1966 Ford 750 heavy-duty truck with an American LaFrance pumper bed. (Courtesy of LFD.)

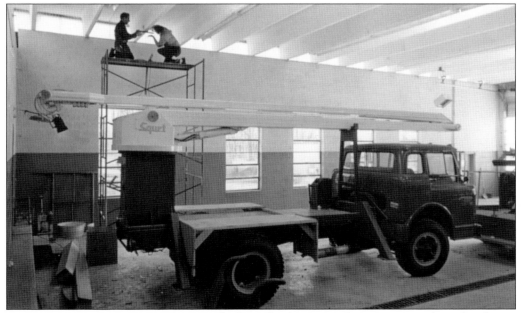

WATER TOWER. Water Tower No. 1 was built in the department's repair garage from the chassis up in 1972. A Squrt 58-foot water tower was installed on the rear of the Ford truck assembly. The boom and nozzle were remotely controlled with a capacity of 1,200 gallons per minute. The truck cost $25,000. (Courtesy of LFD.)

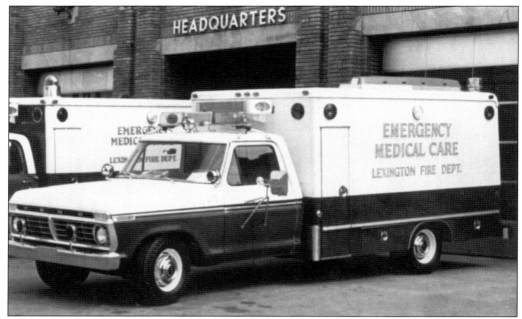

BUGGIES. The LFD refers to ambulances as buggies, a carryover from when the chief's horse-drawn buggy was used to transfer injured firemen. In 1969, the department established an EMT service. It was first equipped with station wagons, which were replaced with Ford light-duty trucks (above) in 1972. These trucks proved unable to hold up under constant use, so Deputy Chief James Caton directed an effort to find a replacement. He assigned Maj. Foxie F. Blanton and Capt. Lionel Gumm of the department's garage to design an improvement buggy. The pair built a new ambulance with a Ford medium-duty truck chassis, with a box body manufactured by a Texas milk truck company. This unit was equipped with a reliable diesel engine and a relocated exhaust system under an extended front bumper. The rear suspension was modified with a beehive spring and airbags. When the rear door opened, the airbags deflated, lowering the back 18 inches. In 1985, Gumm, Blanton, and John H. Burns established Vehicle Systems Inc. to manufacture ambulances in Lexington. The ambulance below was built in 1981. (Both, courtesy of LFD.)

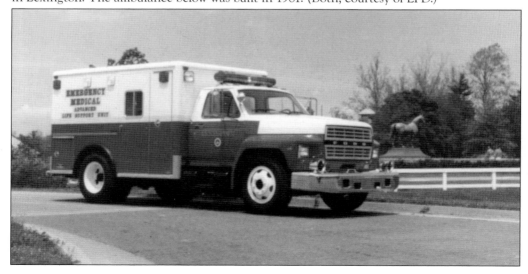

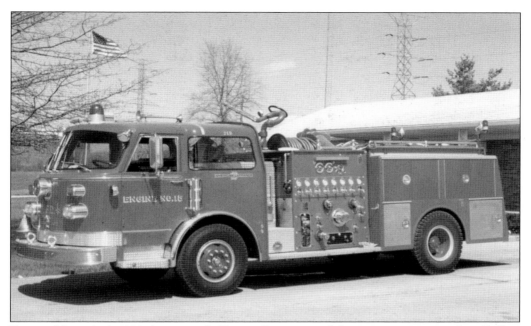

ENGINE NO. 15. A 1979 American LaFrance Century model pumper was assigned to Shillito Station No. 15. The station was opened in 1973 to cover the Nicholasville Road area and is in Shillito Park, adjacent to Fayette Mall. The engine had a capacity of 1,250 gallons per minute with a 500-gallon internal tank. (Courtesy of LFD.)

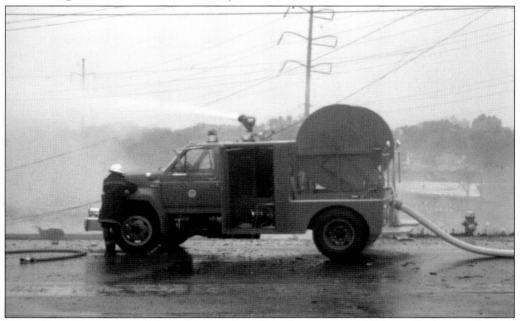

HOSE REEL. Two thousand feet of five-inch hydrant hose was available on the hose reel truck around 1980. The truck provided or supplemented water to fire engines. The truck was also equipped with a turret mounted on the roof. The motorized reel allowed retrieval of the hose by backing along the deployed line toward the hydrant. (Courtesy of LFD.)

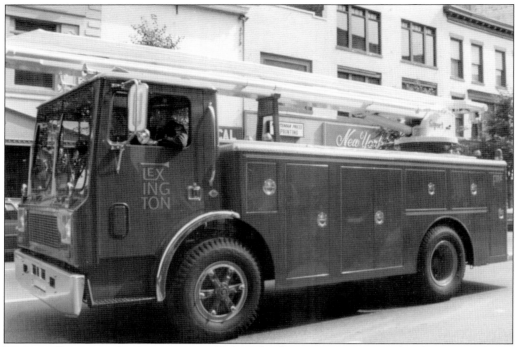

JOYSTICK CONTROL. A telesquirt was added to the fleet in 1984, equipped with an articulating water tower controlled by a joystick. The boom was 75 feet with a pumping capacity of 1,000 gallons per minute. The control panel on the rear of the truck allowed one man to operate the unit. The attachment cost $31,688 plus the cost of the truck. (Courtesy of LFD.)

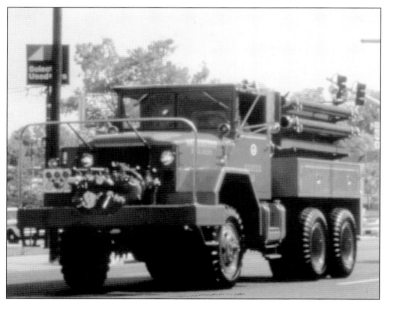

TANKER. Engine Three was built by Capt. Lionel Gumm of the fleet service garage in 1983 using an Army surplus 1966 Kaiser five-ton truck. The six-wheeled engine carried 1,200 gallons of water, with a 750-gallon-per-minute pump installed on the front bumper. The engine was used for off-road locations and grass fires. (Courtesy of LFD.)

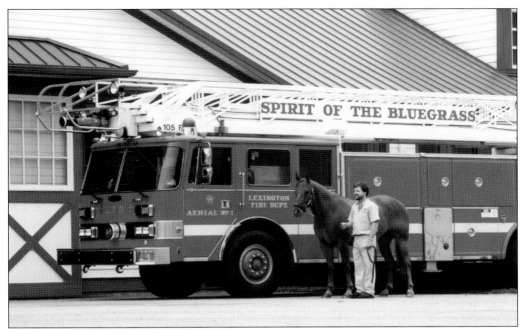

Spirit of the Bluegrass. Aerial No. 1 was a 1987 Pierce Arrow ladder truck stationed at the Central Fire Station. The ladder could reach a height of 105 feet. The aerial was later assigned to Woodland Firehouse No. 5 as Aerial No. 2. It was retired around 2010. (Courtesy of LFD.)

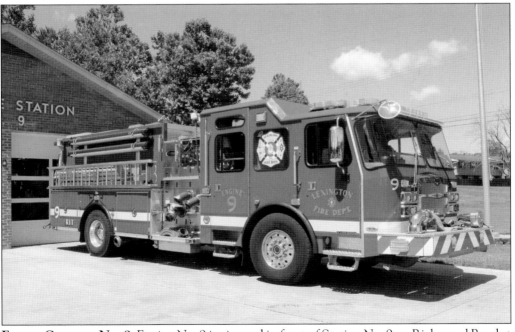

Engine Company No. 9. Engine No. 9 is pictured in front of Station No. 9 on Richmond Road at the reservoir. Engine No. 9 is a 1,500 gallon-per-minute 2016 E-ONE Typhoon. Engine Company No. 9 was formed in 1964 and temporarily housed in Firehouse No. 5. After the completion of Station No. 9, the company was relocated in 1966. (Courtesy of Greenlee.)

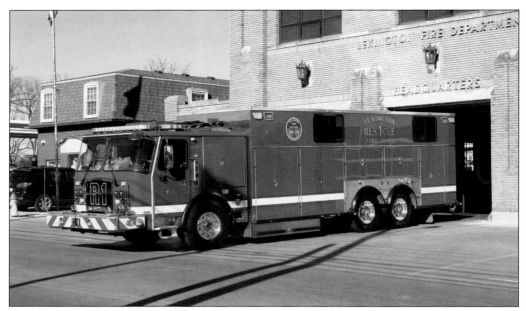

Rescue No. 1. Established in 2005, Rescue Company No. 1 is located at the old station on Merino Street. The company is a heavy rescue unit specially trained for rescues such as swift water, diving, machinery entrapment, trench collapse, and building collapse. In addition, the unit is also trained in large animal rescue. Pictured here is a 2017 E-ONE in front of the Central Station. (Courtesy of Greenlee.)

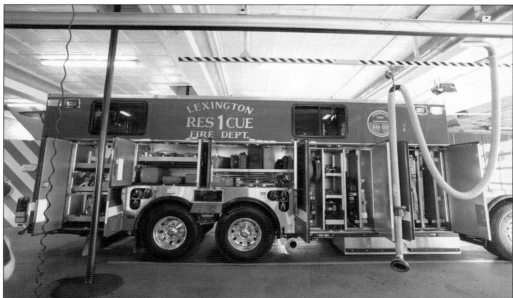

Special Design. A new Rescue No. 1 entered service in 2017 with a specially designed E-ONE Cyclone unit. The walk-in body holds five firefighters, in addition to the two in the cab. The compartments carry a Stokes basket, backboards, ladders, hydraulic spreaders, cutters, oxygen cylinders for diving, and an inflatable raft. The extended front bumper is equipped with a 15,000-pound winch. The truck cost $826,278 with $91,483 in equipment. (Courtesy of LFD.)

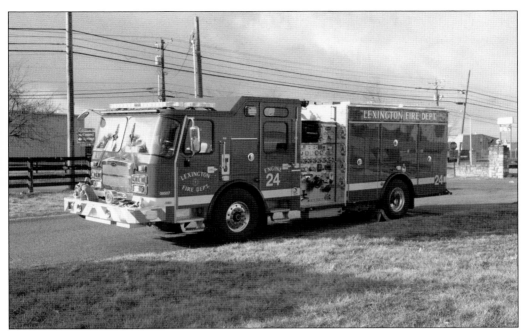

Engine No. 24. Housed in the new Station No. 24 on Magnolia Springs Drive, Engine No. 24 is a 2019 E-ONE Typhoon with a capacity of 1,500 gallons per minute. The engine operates in tandem for county fires outside city limits with Tanker No. 1, a 2019 E-ONE Cyclone 3,000-gallon tanker. (Courtesy of Greenlee.)

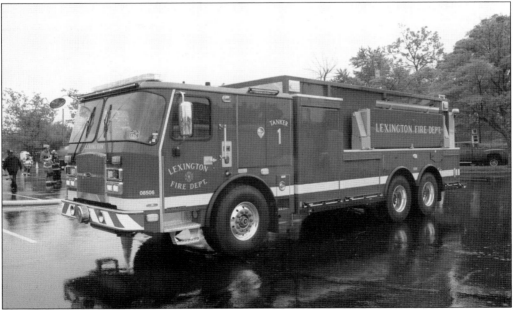

Tanker No. 1. The 2019 E-ONE Cyclone tanker responds to fires in the rural areas of Fayette County not covered by hydrants. Under the command of a lieutenant and driver, the engine is housed at the new Station No. 24. The pumper has a capacity of 1,000 gallons per minute, with a reserve tank of 3,000 gallons. (Courtesy of Greenlee.)

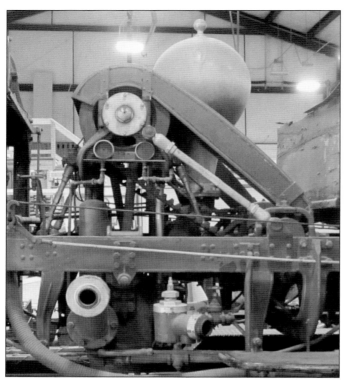

WHERE ARE THE INSTRUCTIONS? The pump on the 1911 Knox pumper at left was controlled by two valves (water input and output), and the pressure was increased by the throttle of the engine. The pumper had two gauges for water input and output pressure. Today, the control panel of a 2019 E-ONE (below) still has the master gauges for input and output pressure, plus gauges and control valves for each outlet, controls for water, foam solutions, engine and air compressor controls and gauges, and water and foam lever gauges and warning lights. In addition, the engine has an air outlet for filling a flat tire.

About the Lexington History Museum

The Lexington History Museum Inc. is a 501(c)3 not-for-profit organization that engages all people in the discovery and interpretation of the history of Lexington, Kentucky, and the Bluegrass Region.

Incorporated in 1999, the Lexington History Museum Inc. opened in the historic former Fayette County Courthouse in October 2003 in a partnership with the Lexington-Fayette Urban County Government. After nine successful years in the old courthouse, the museum had to move out when the building was closed in 2012 to undergo renovations.

Despite not having a permanent home, the museum has continued to actively collect information and resources on Lexington's history and to offer exhibits to the public.

LEXHistory was recognized by Commerce Lexington with the 2017 Phoenix Award.

The museum has had several ambitious goals in the past that include enlarging its endowment; expanding its video documentary history series, Chronicles; continuing to build its Museum in the Cloud virtual 3D reality exhibits; assisting Lexington in celebrating its 250th anniversary in 2025; launching the Lexington History Press; partnering with Radio Eye to air a multi-edition audio history of Lexington; developing partnerships with the history departments of the University of Kentucky and Transylvania University; and converting the Adam Rankin House in the South Hill Historic District into a new house museum with offices and exhibit space.

Discover Thousands of Local History Books Featuring Millions of Vintage Images

Arcadia Publishing, the leading local history publisher in the United States, is committed to making history accessible and meaningful through publishing books that celebrate and preserve the heritage of America's people and places.

Find more books like this at
www.arcadiapublishing.com

Search for your hometown history, your old stomping grounds, and even your favorite sports team.

Consistent with our mission to preserve history on a local level, this book was printed in South Carolina on American-made paper and manufactured entirely in the United States. Products carrying the accredited Forest Stewardship Council (FSC) label are printed on 100 percent FSC-certified paper.